KICKLIY

IMPRESSIONS OF THE MASTER

BOOKS

ISBN 978-1-941250-13-6
First Edition, OCTOBER 2016
Printed in France.

DISTRIBUTED TO THE TRADE BY
Consortium Book Sales & Distribution
LLC. 34 Thirteenth Avenue NE
Suite 101, Minneapolis, MN 55413-1007.
cbsd.com, Orders: (800) 283-3572

ododbooks.com

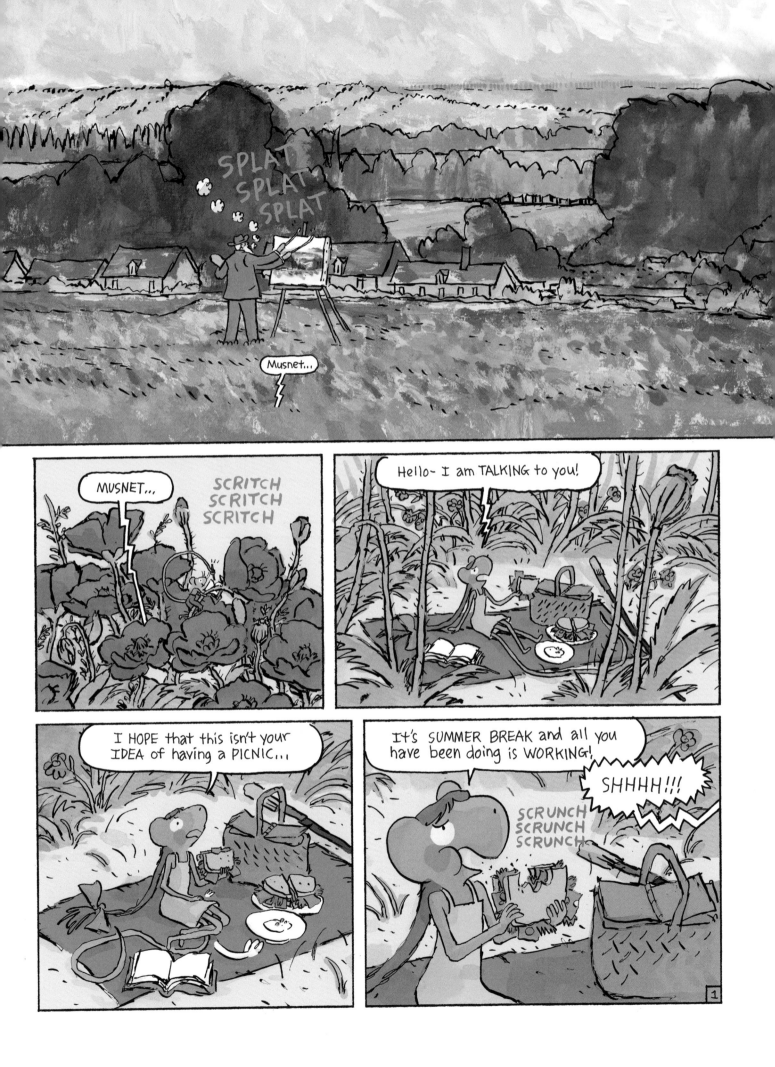

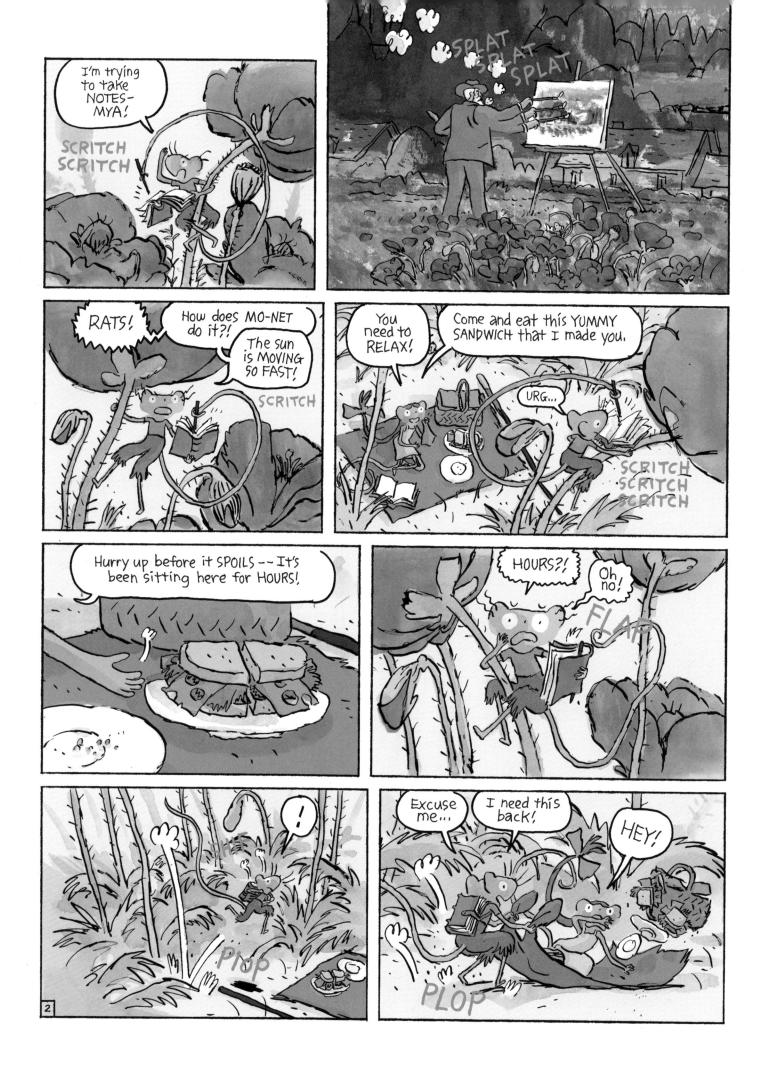

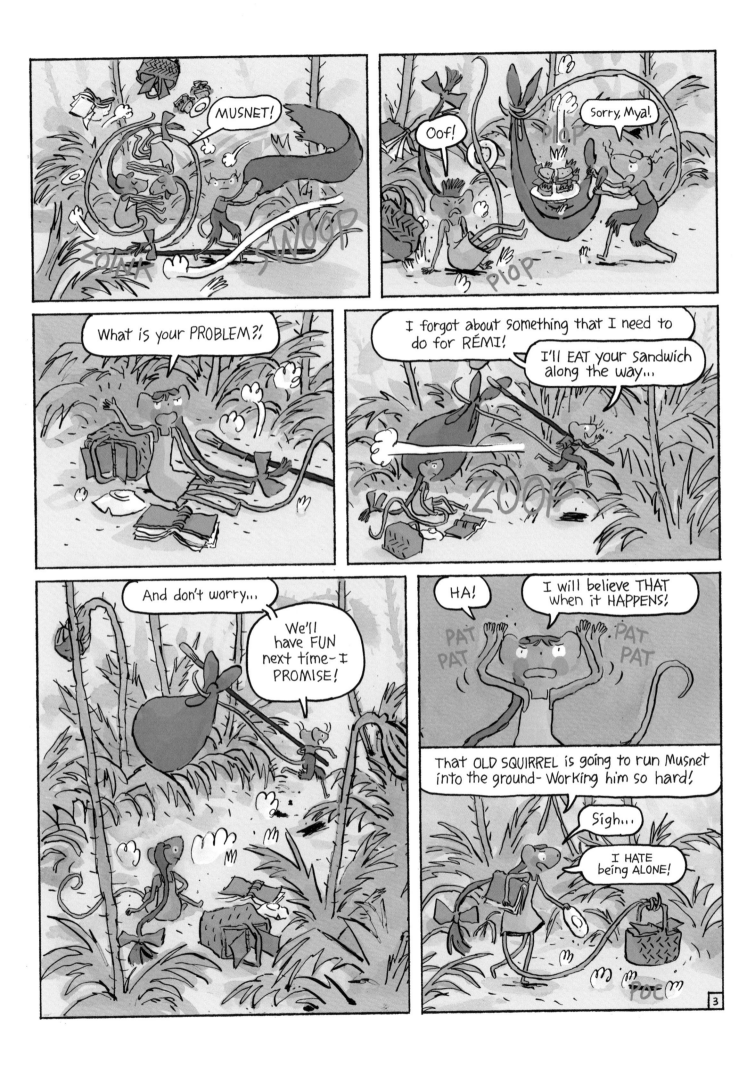

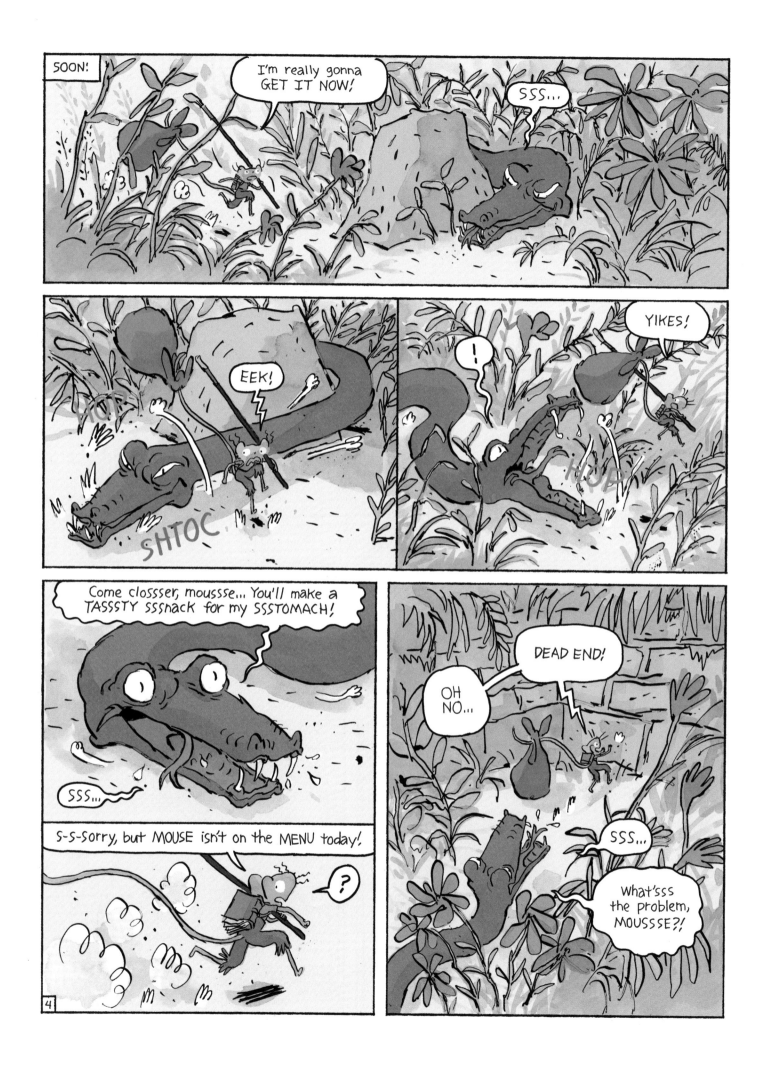

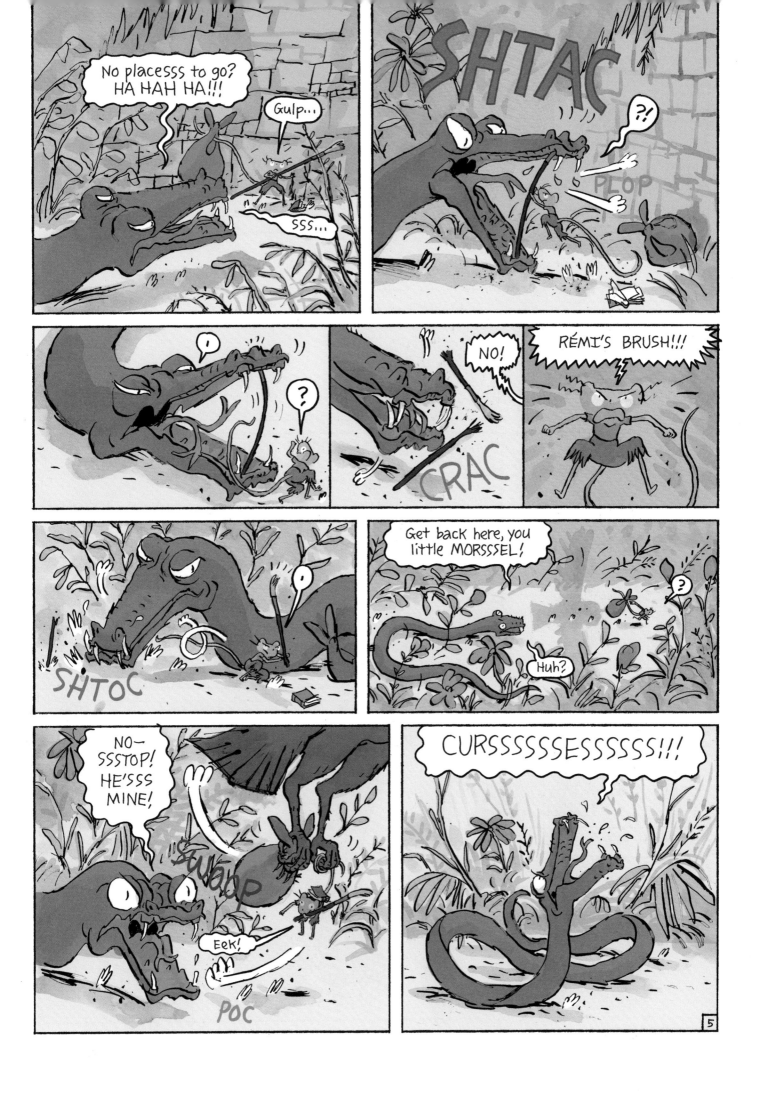

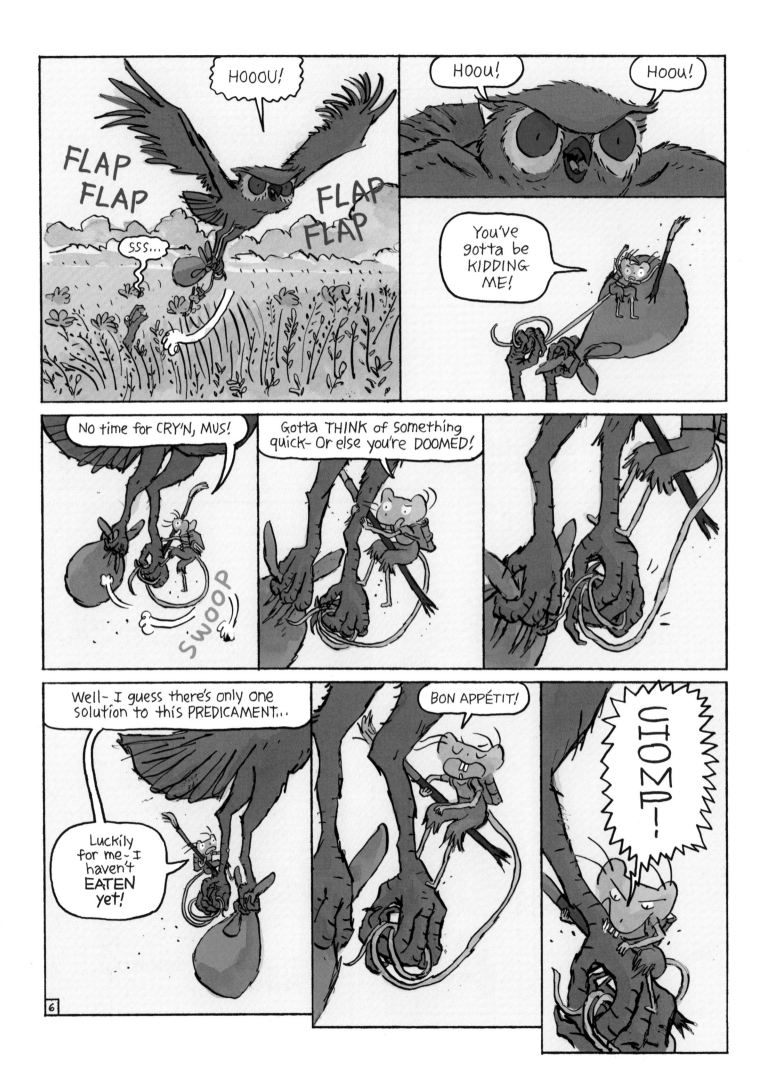

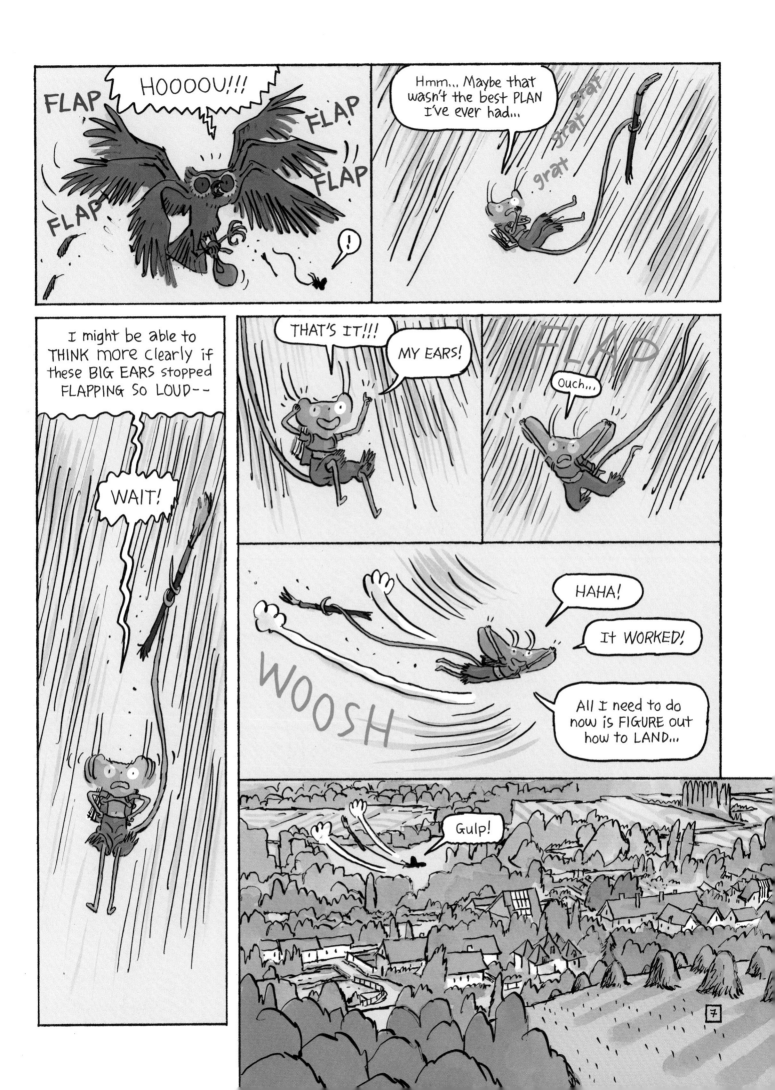

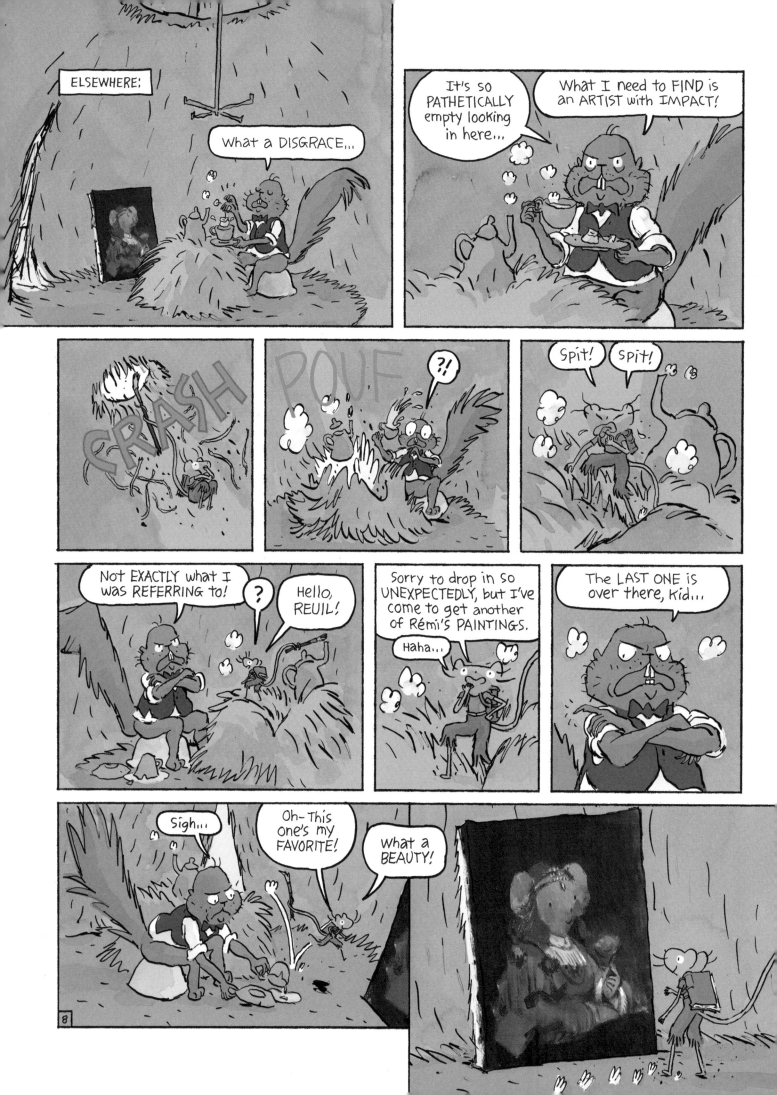

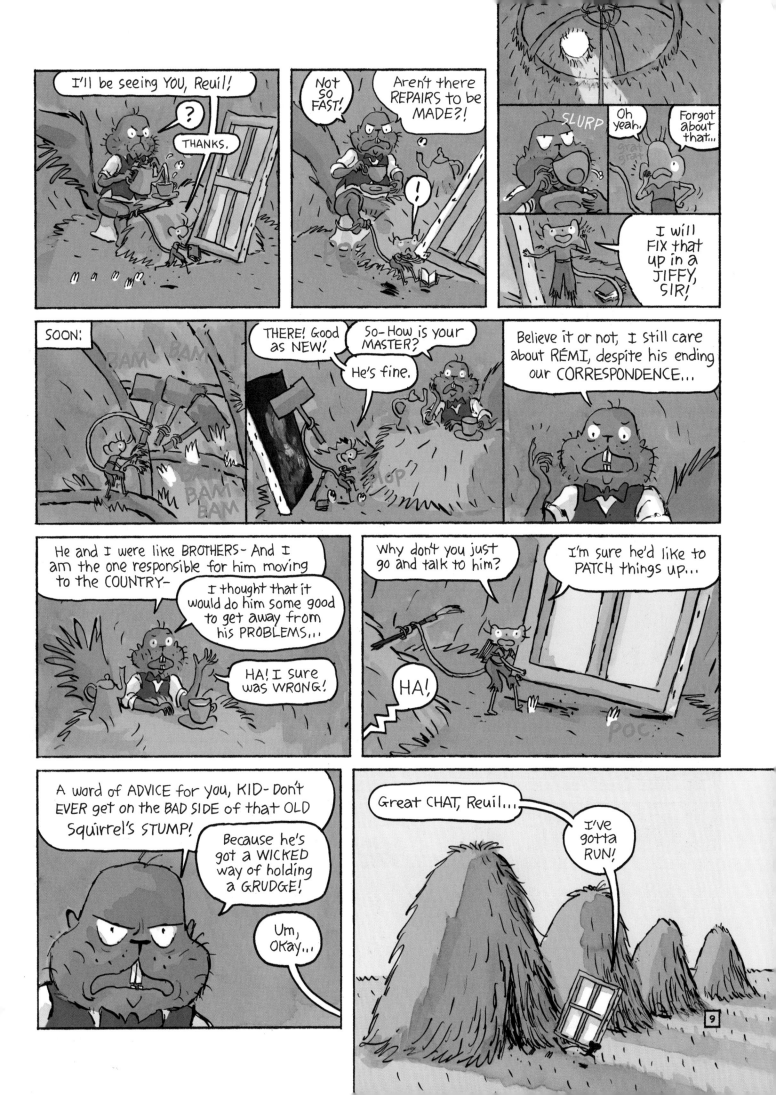

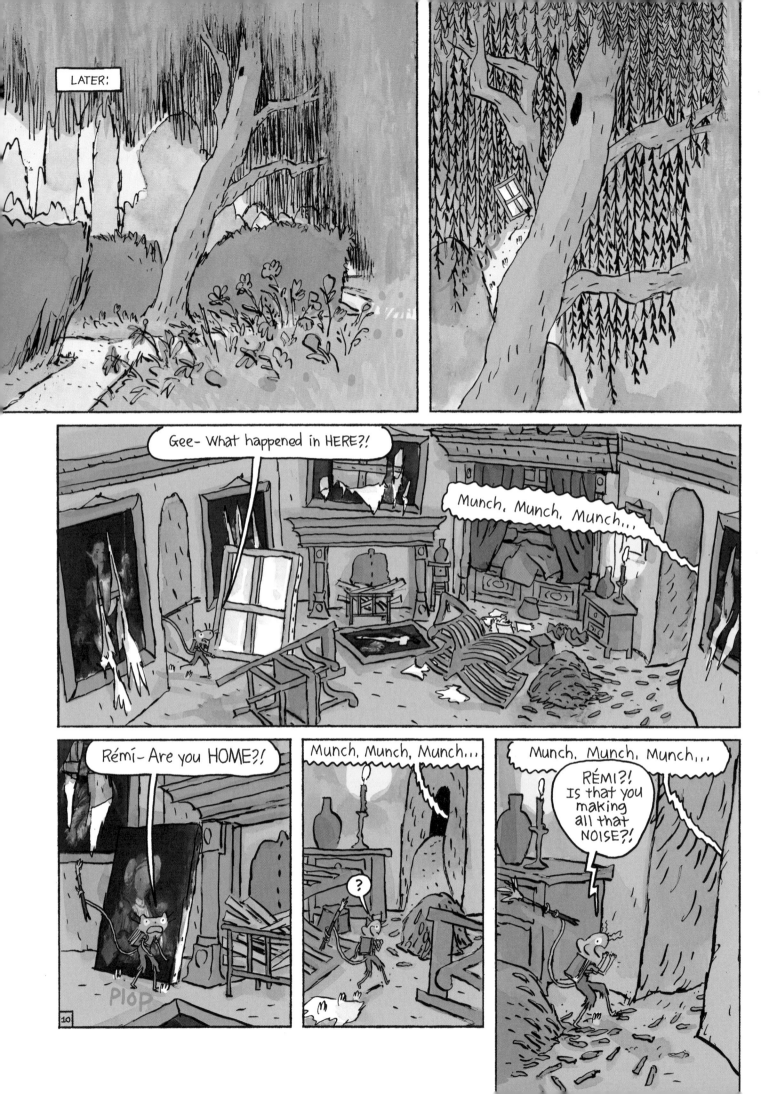

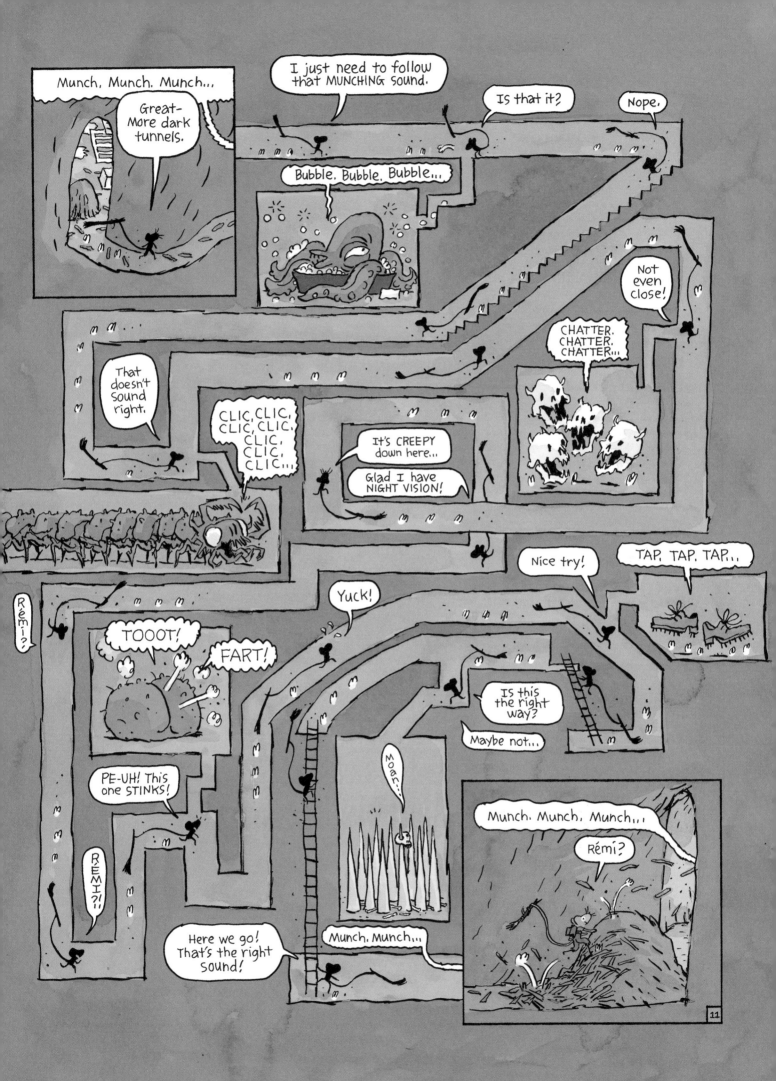

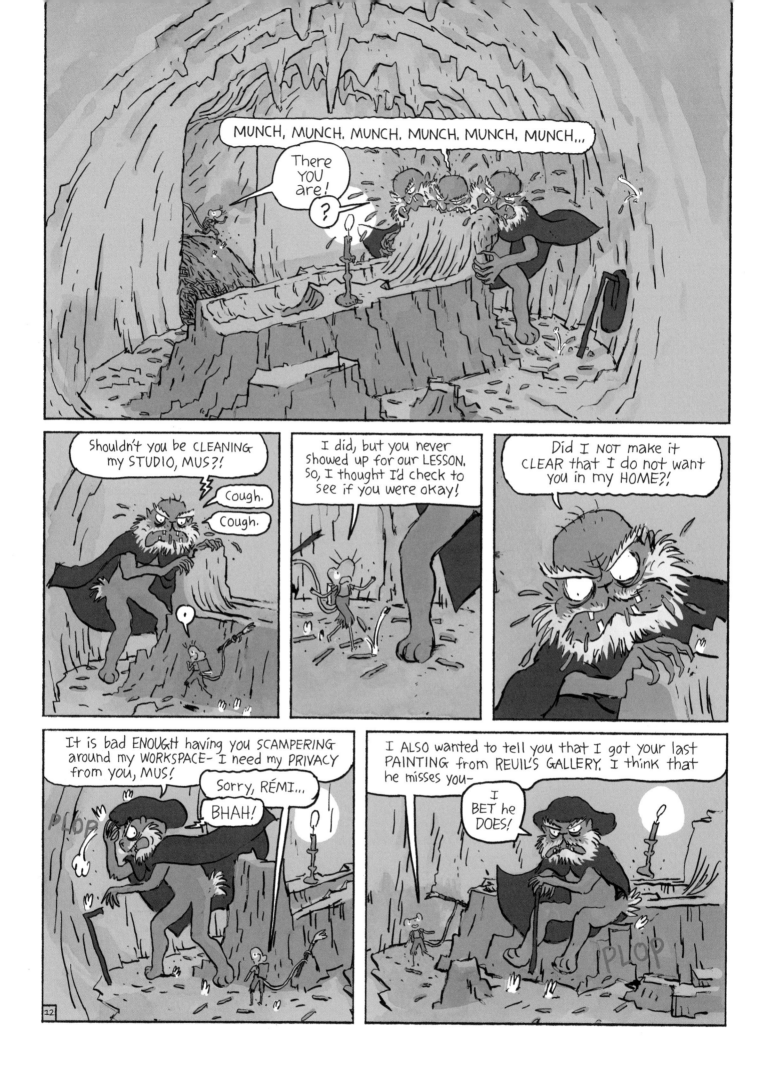

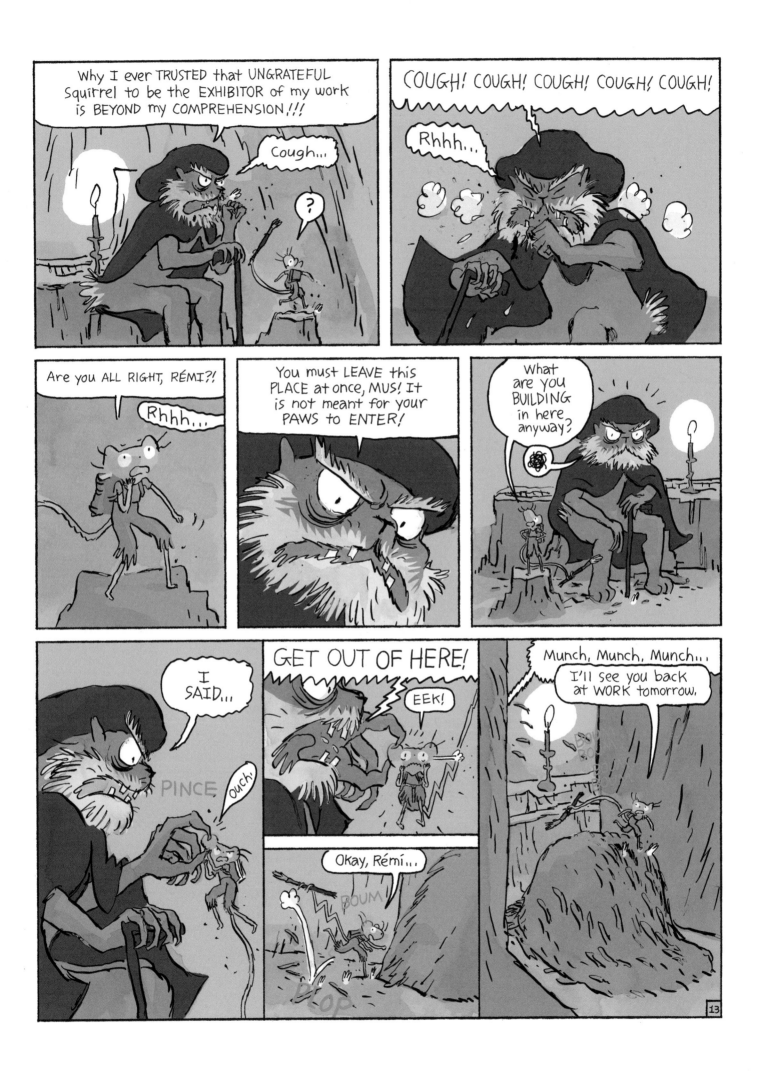

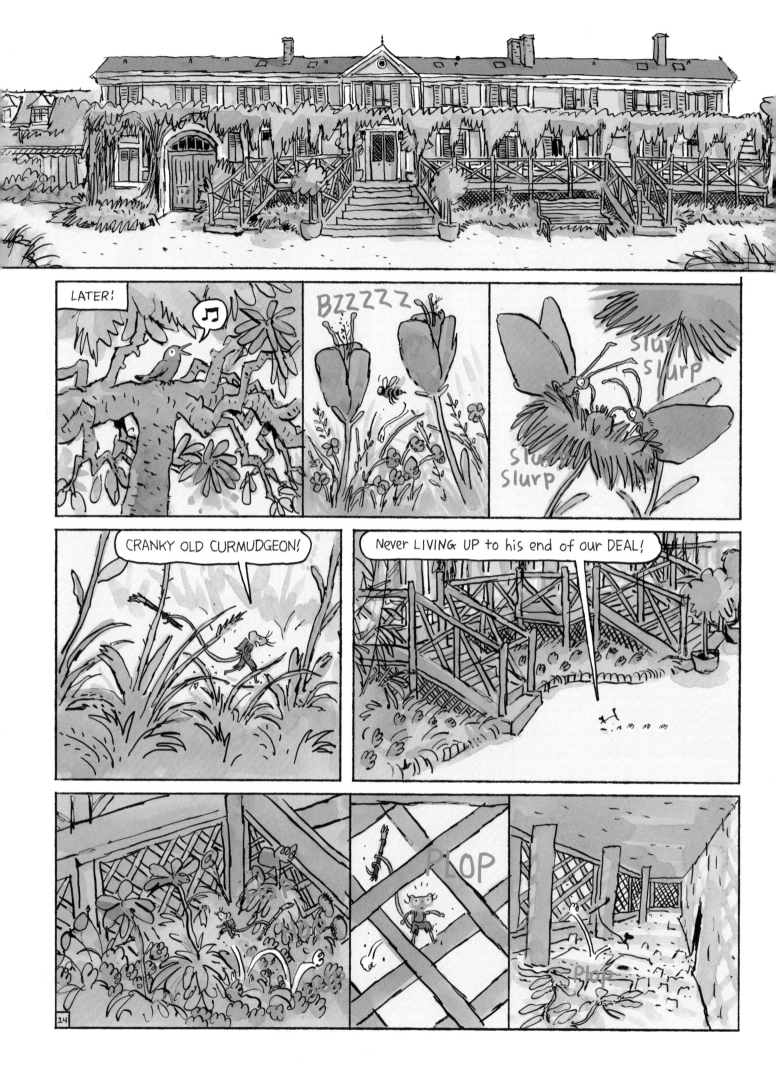

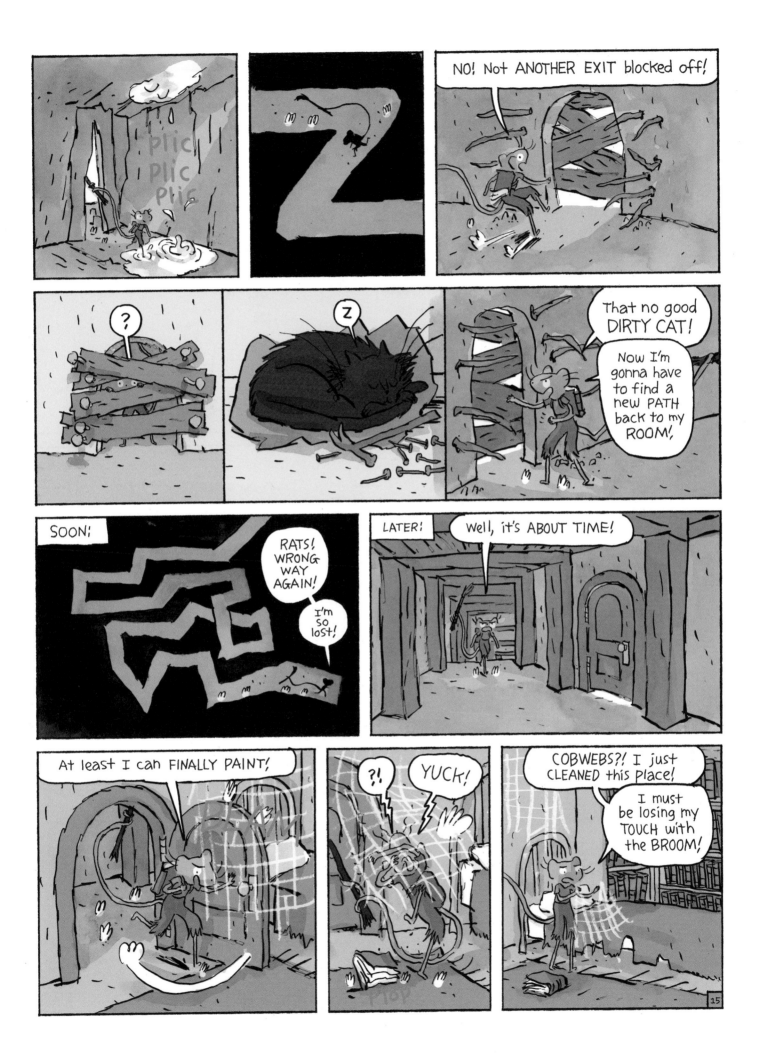

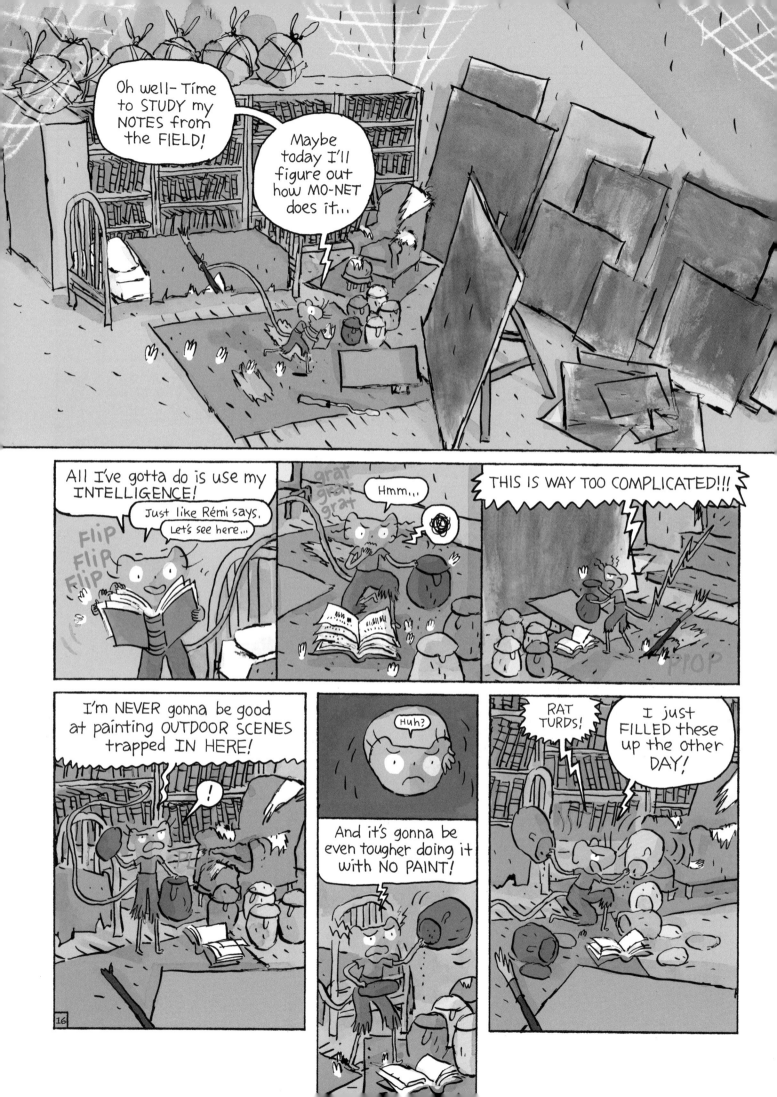

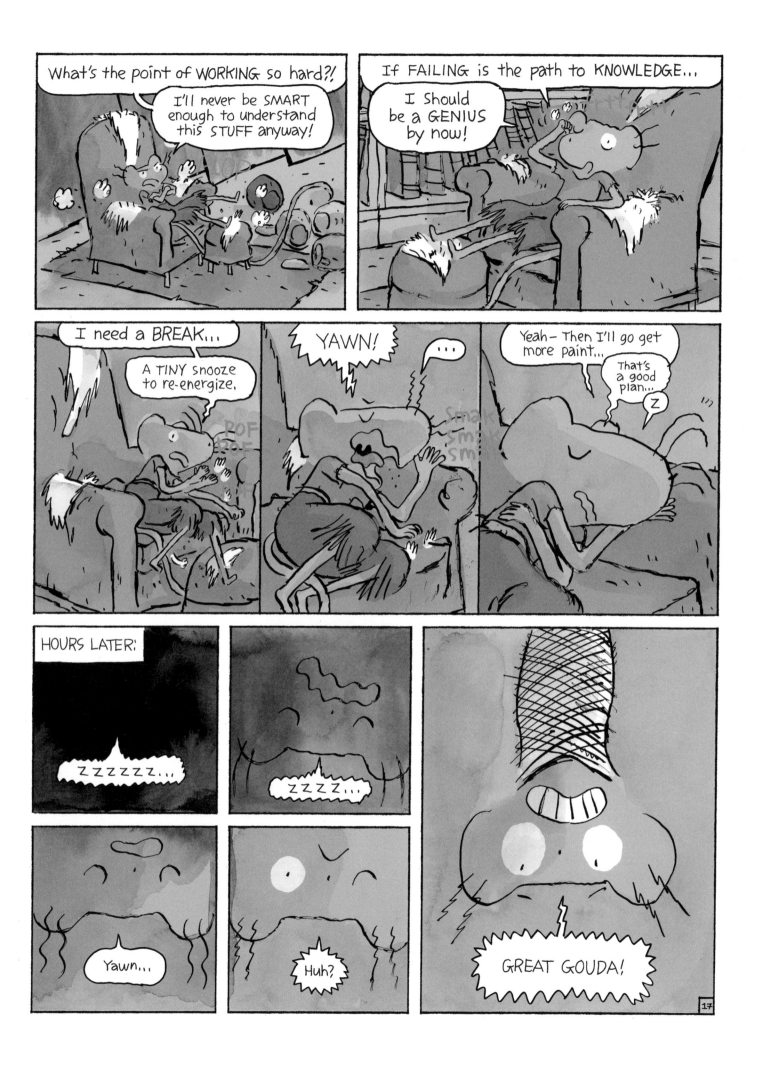

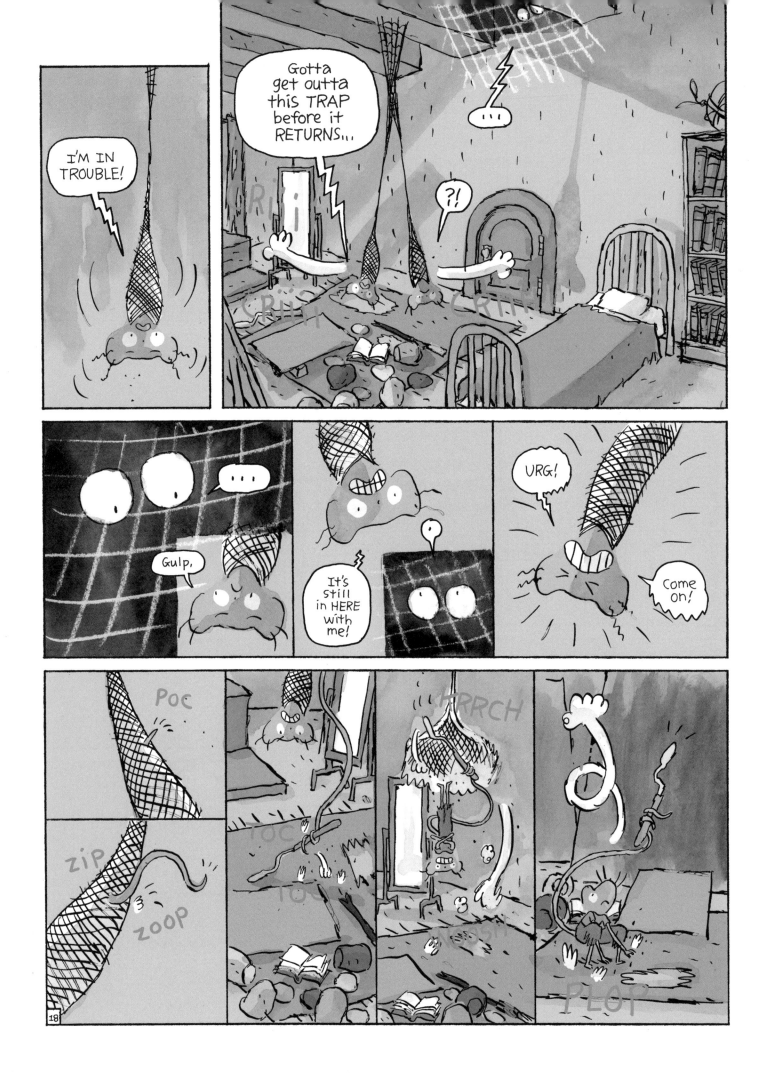

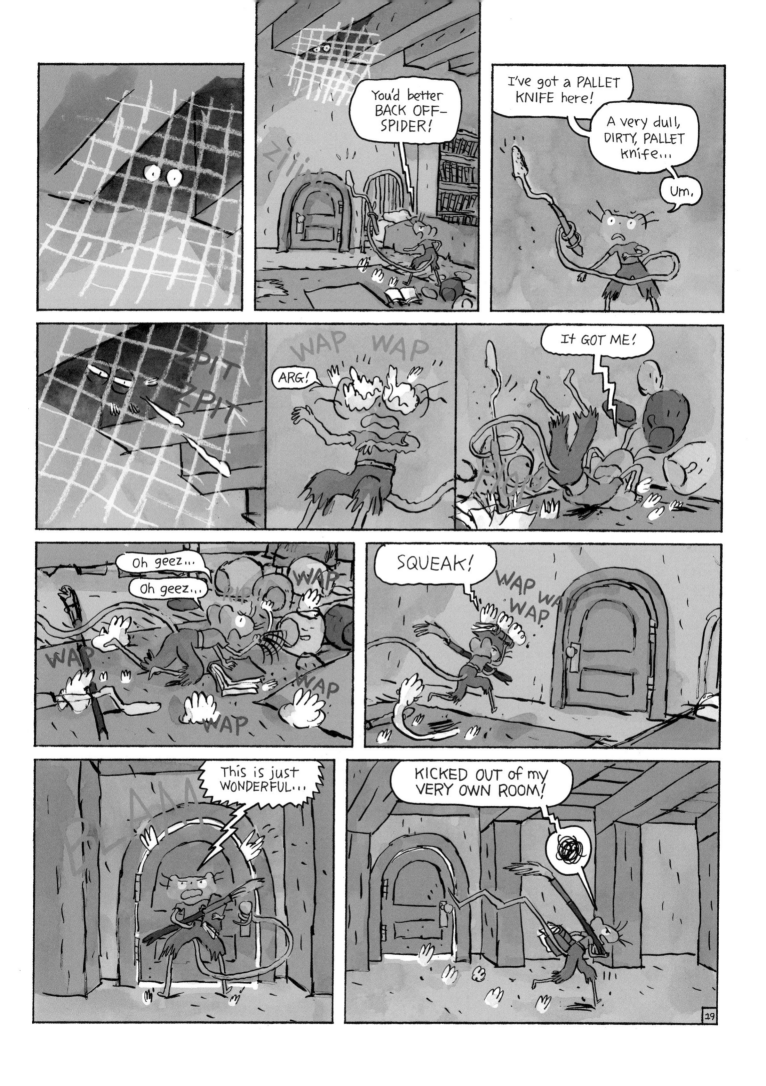

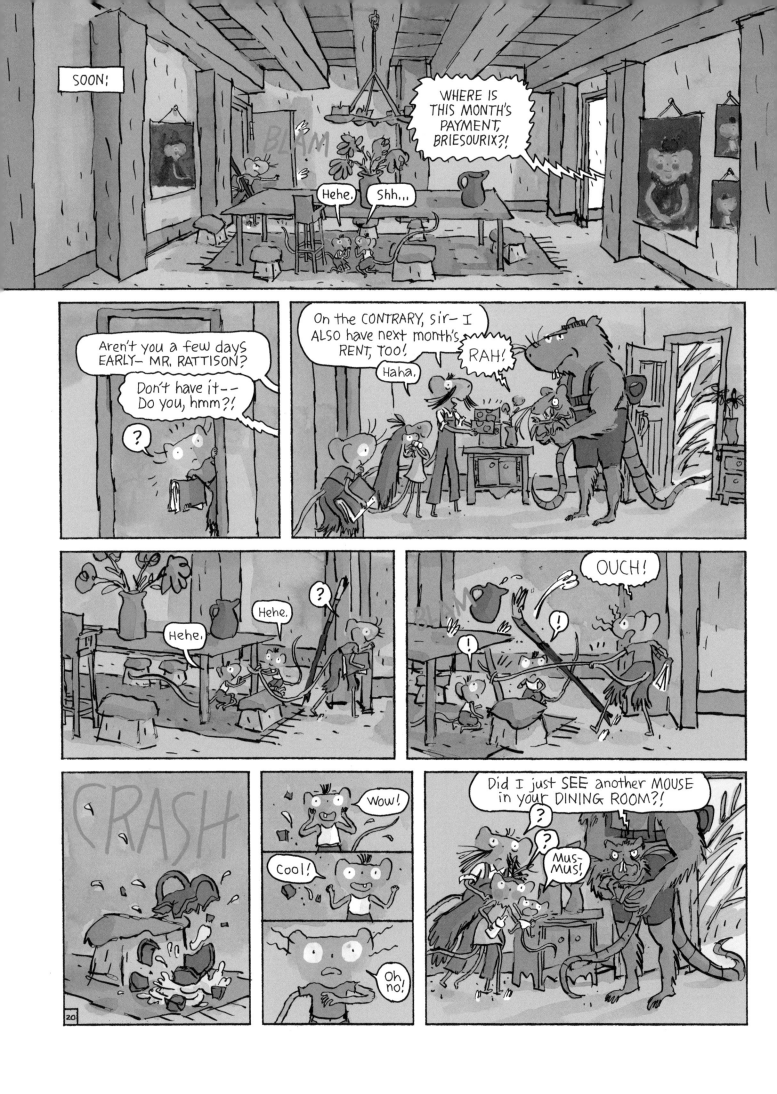

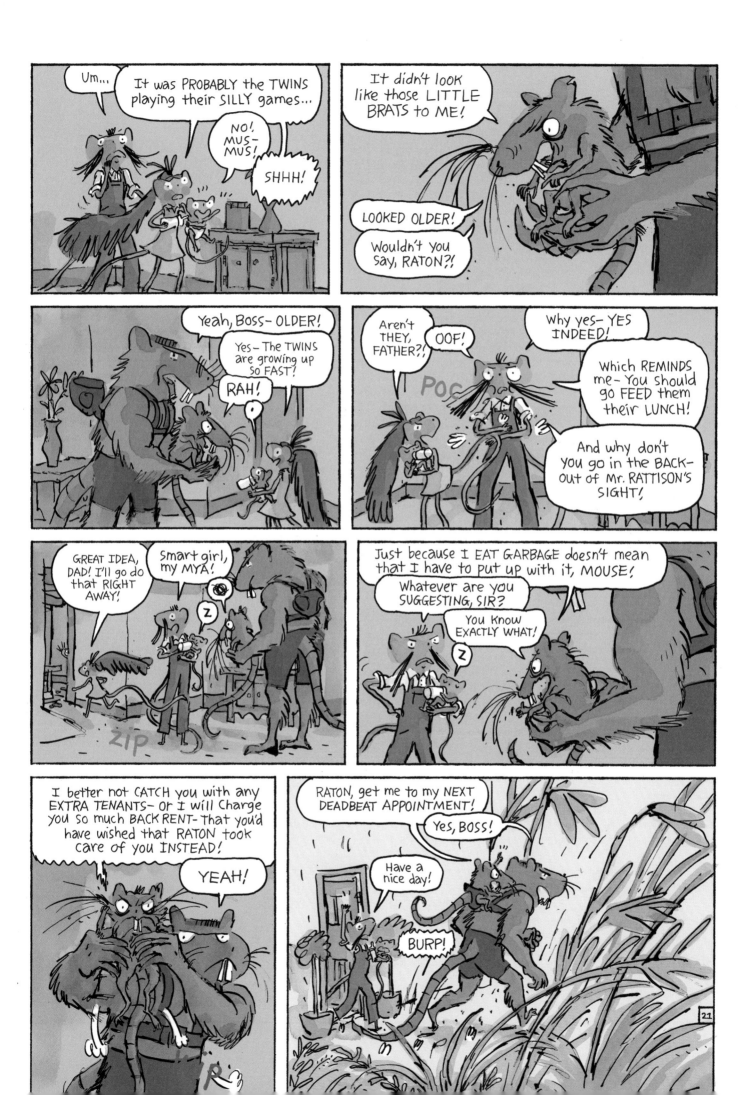

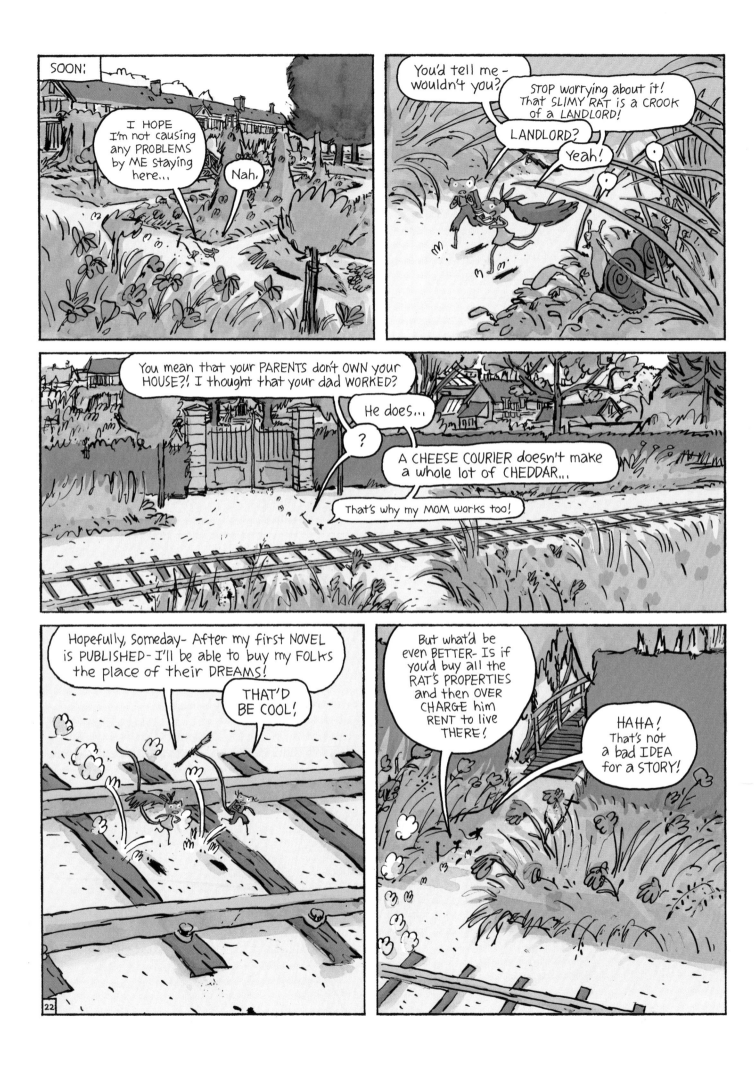

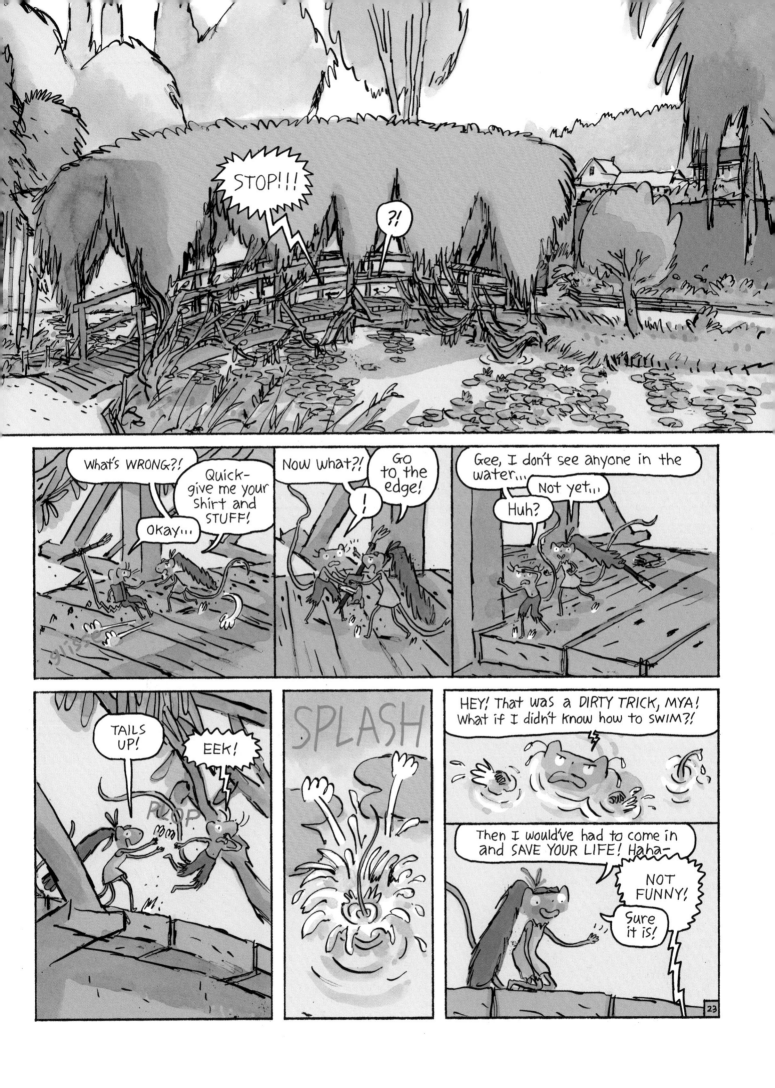

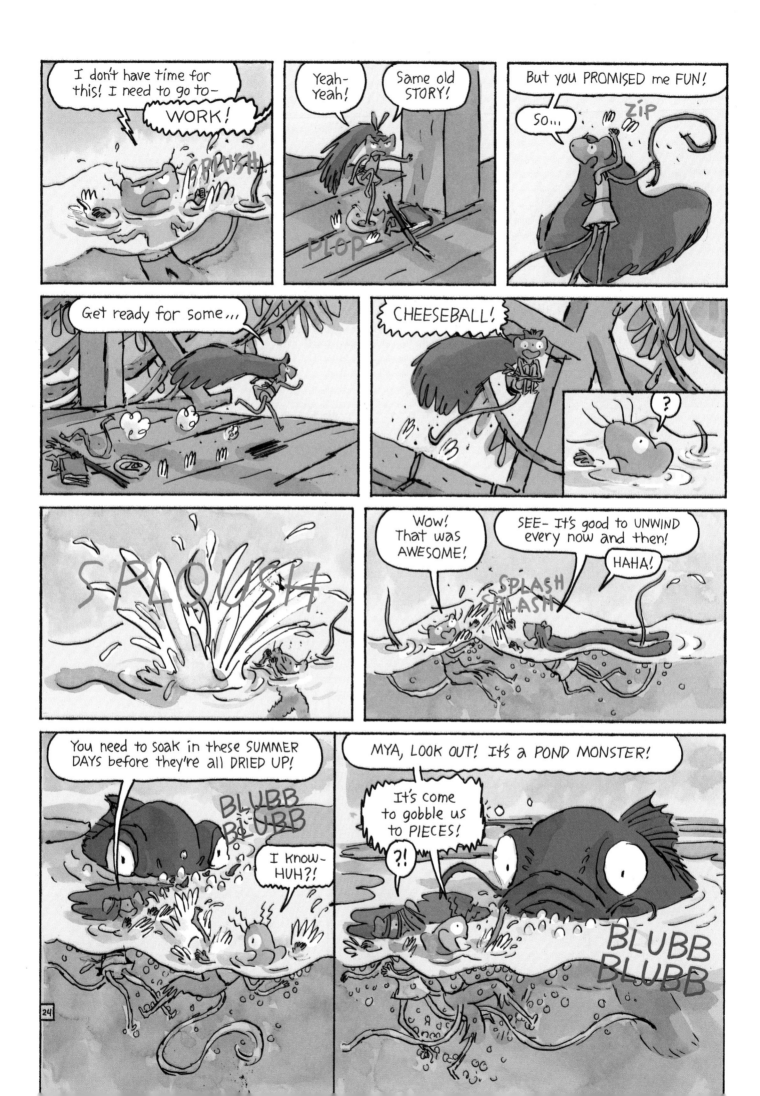

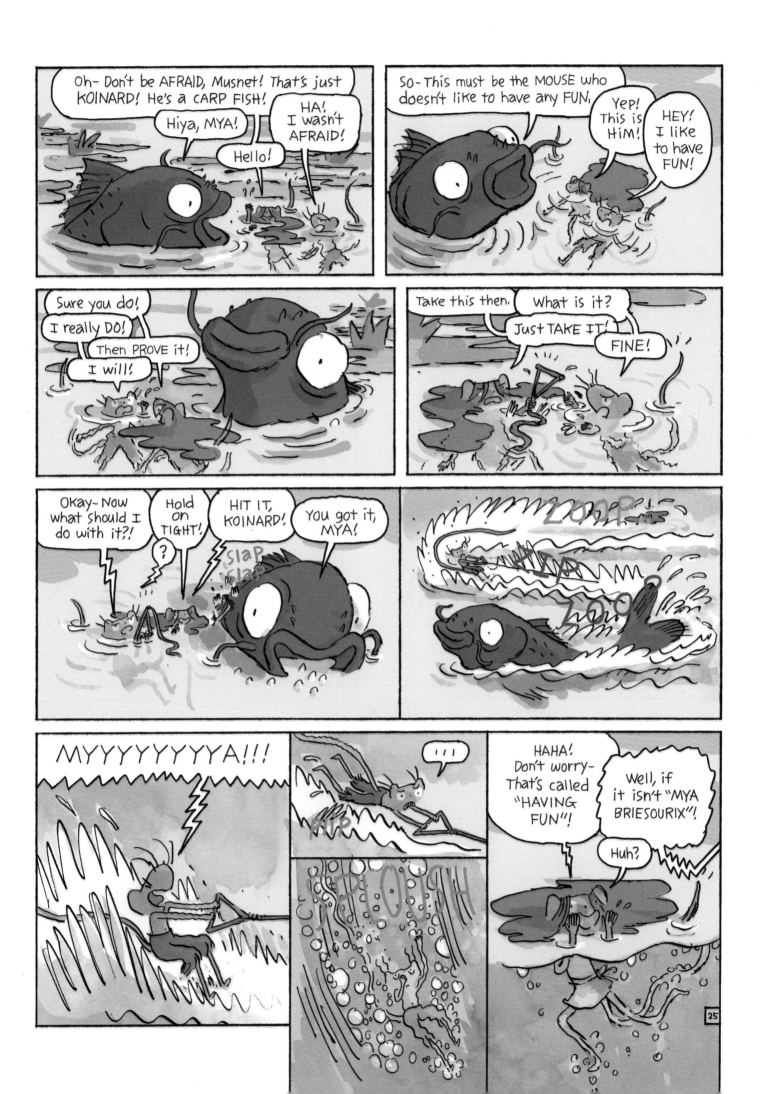

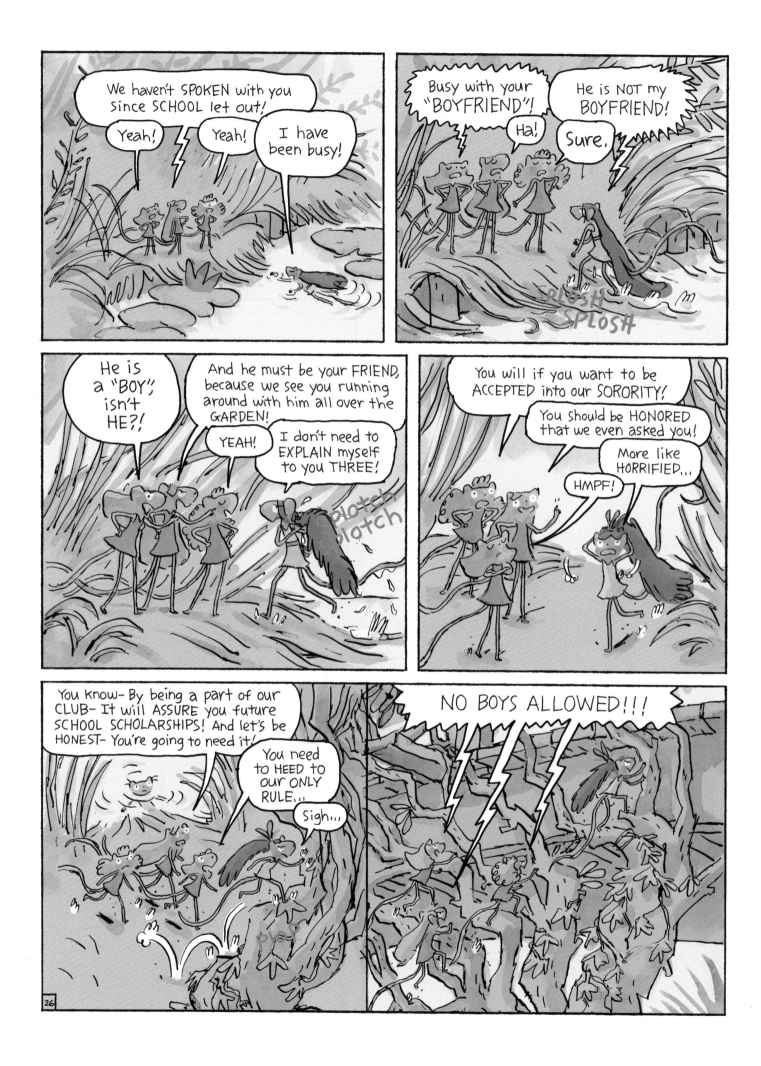

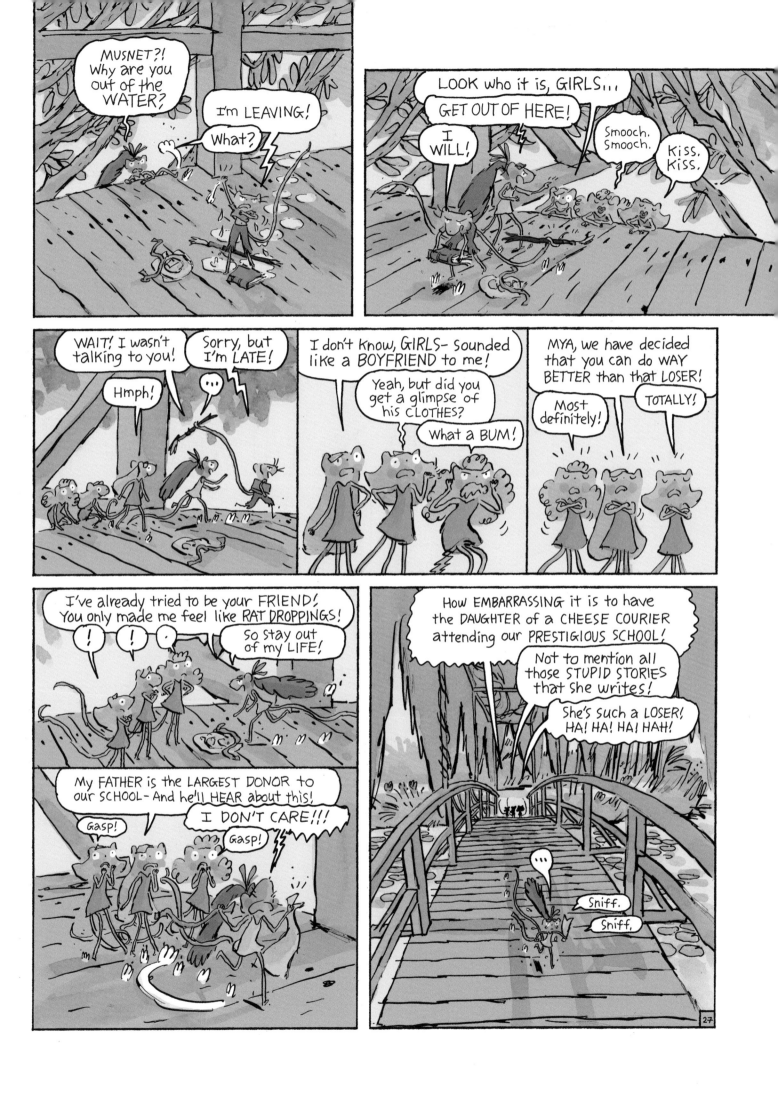

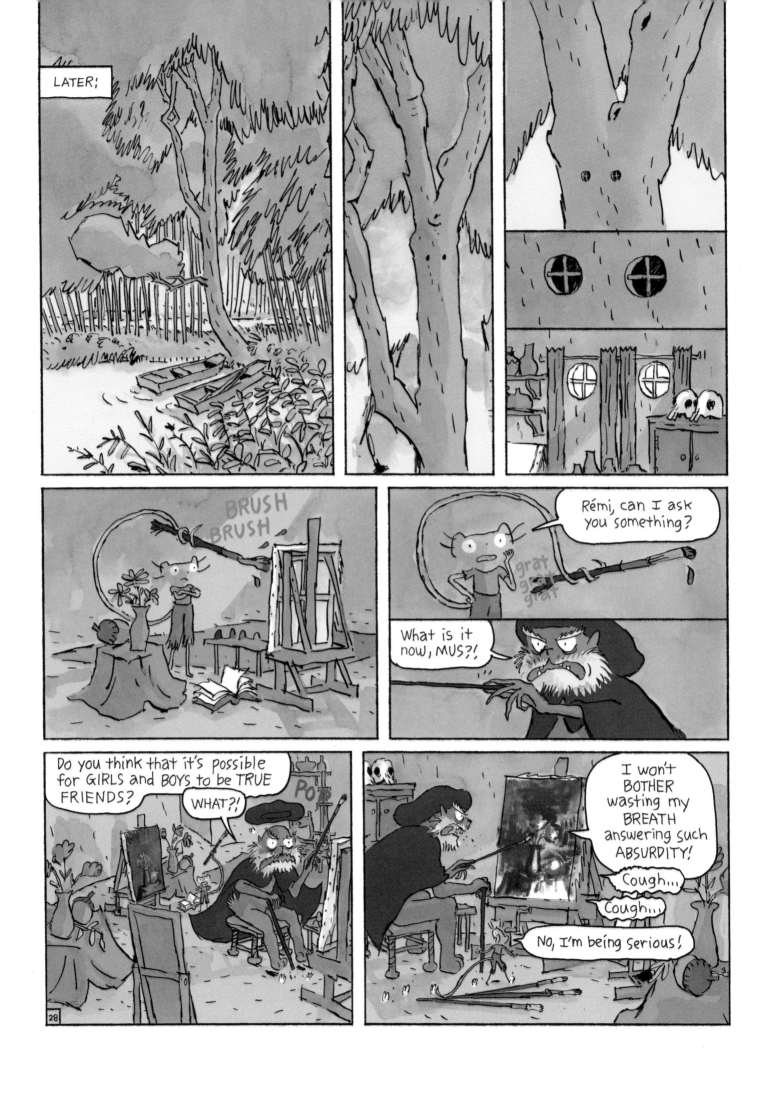

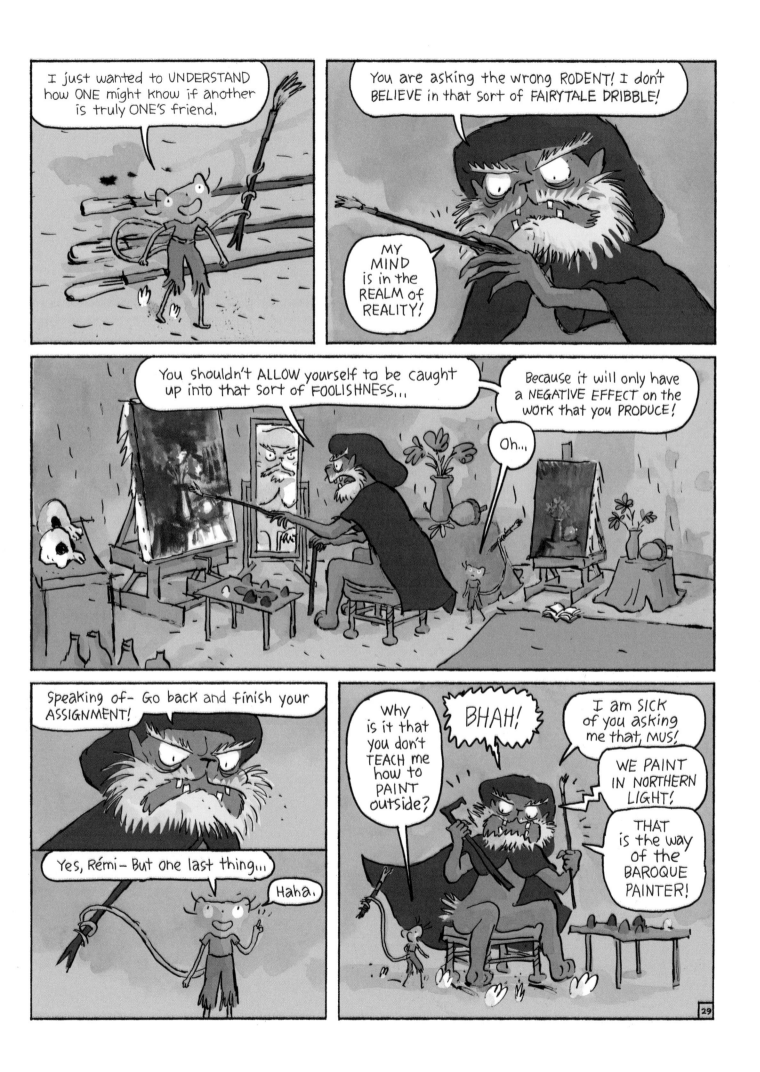

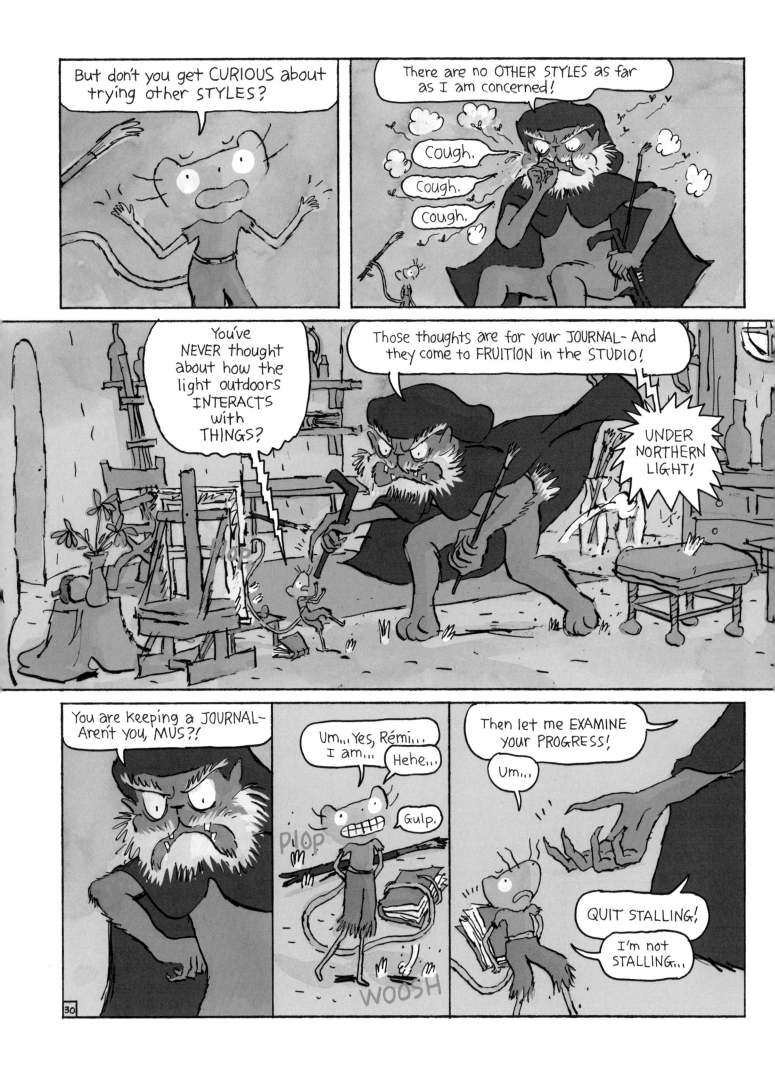

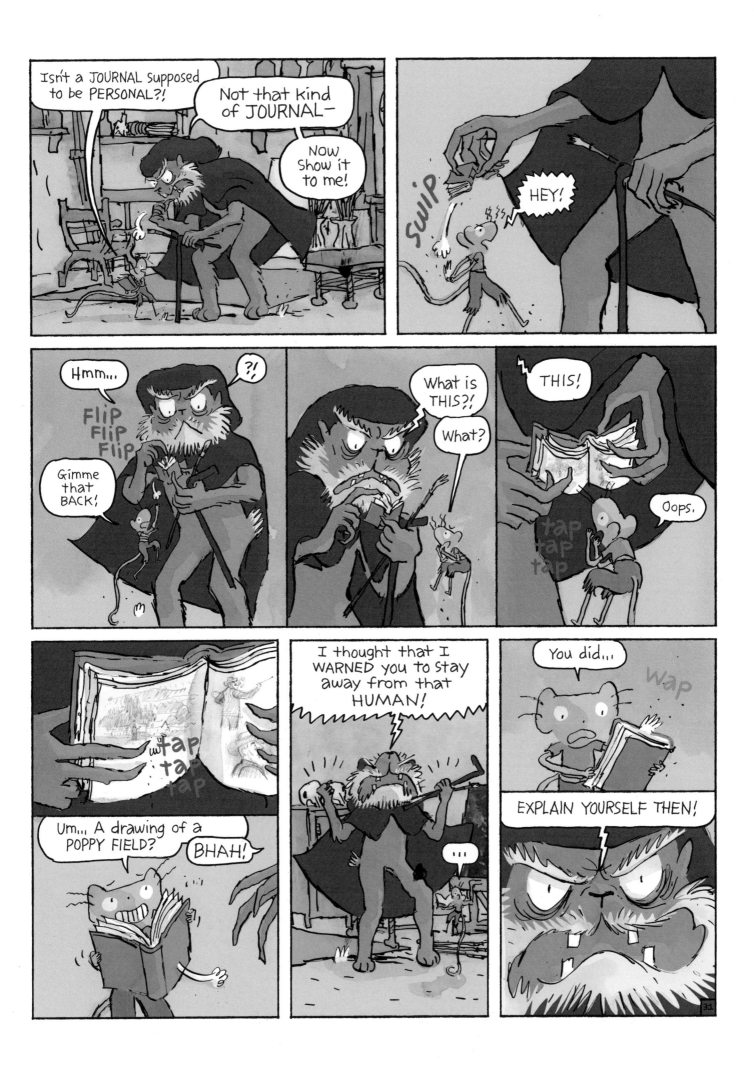

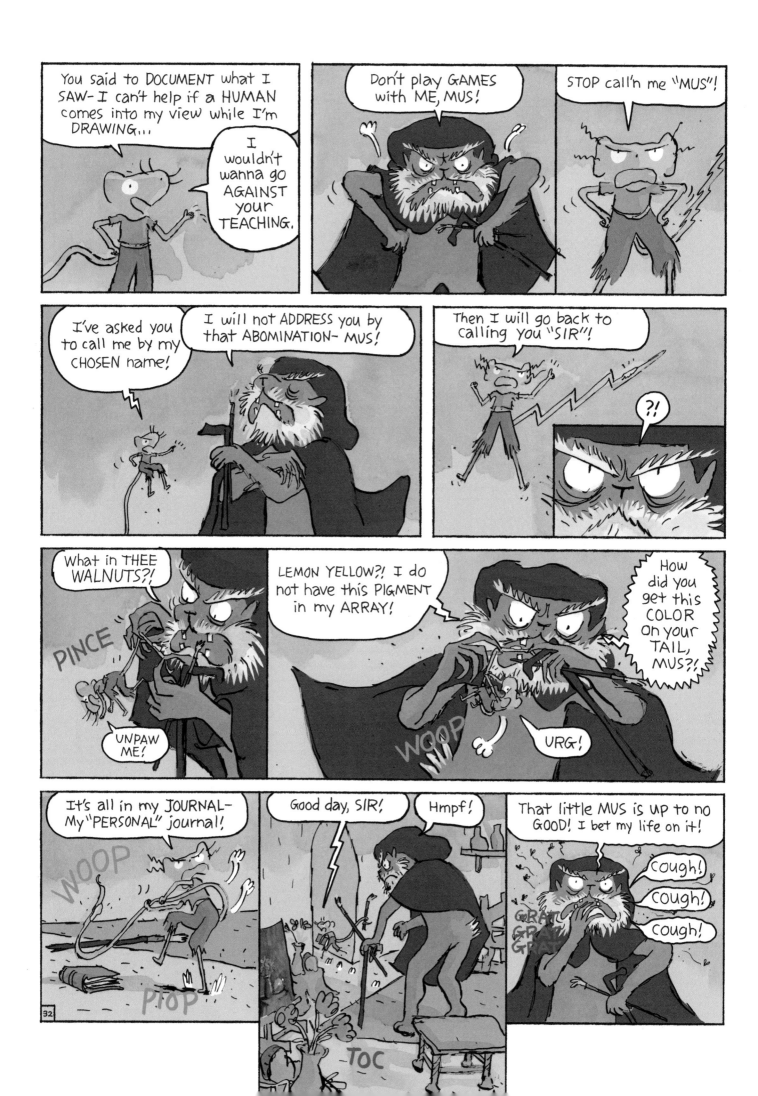

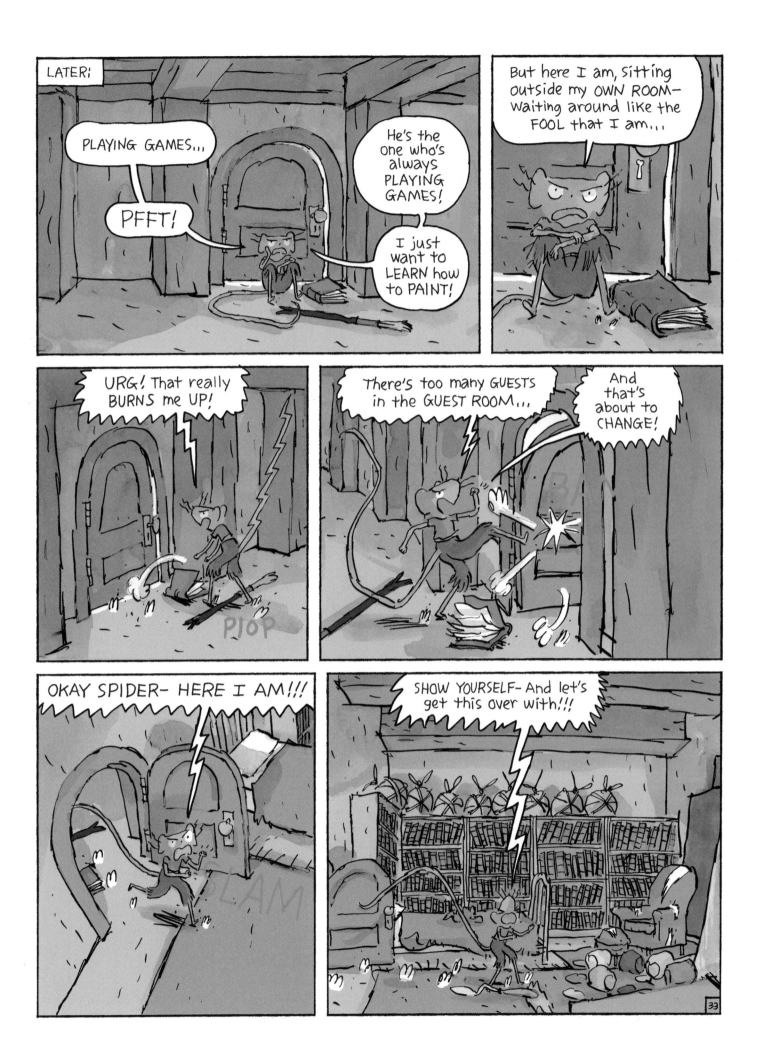

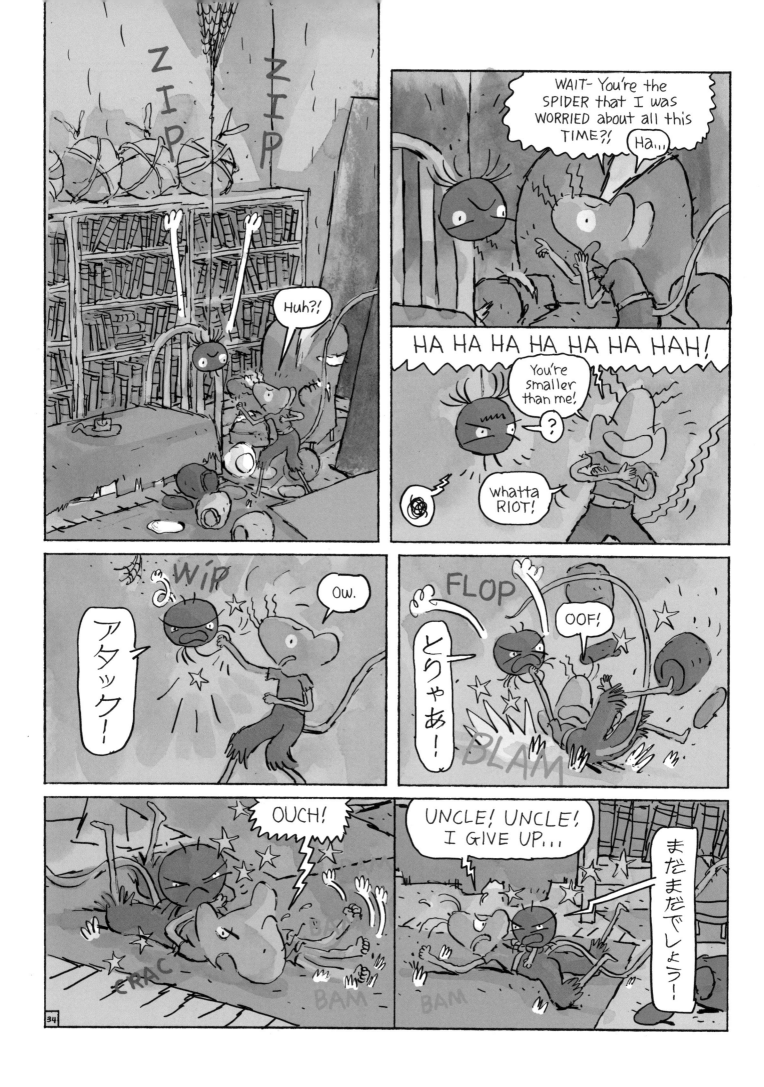

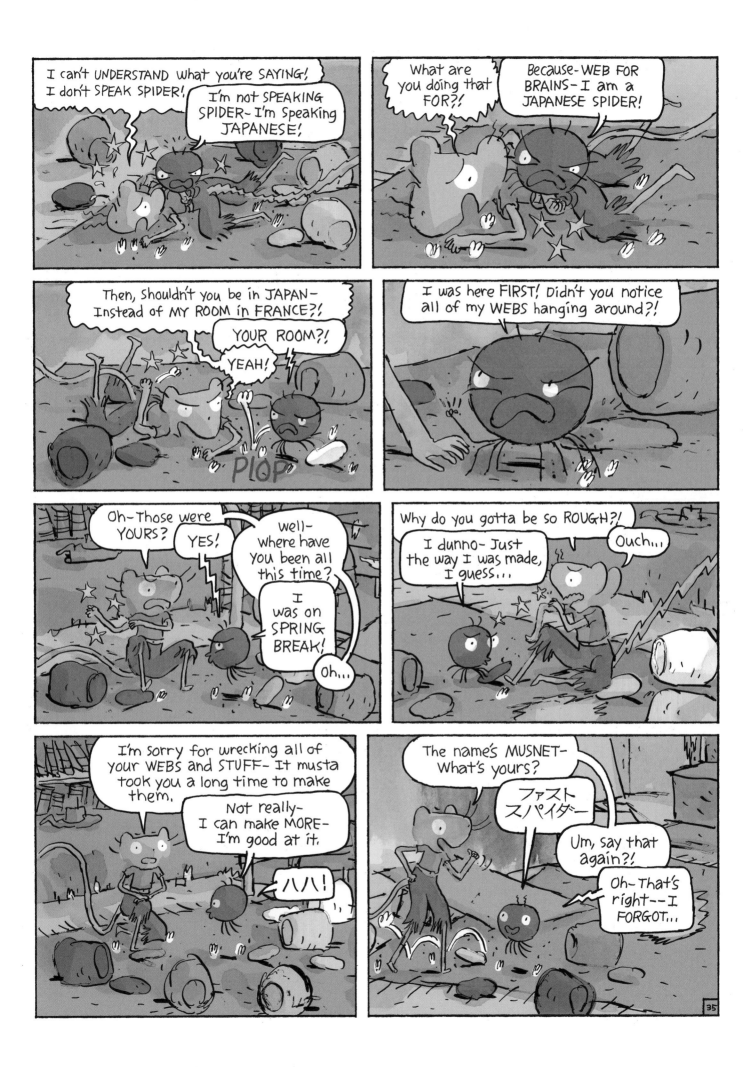

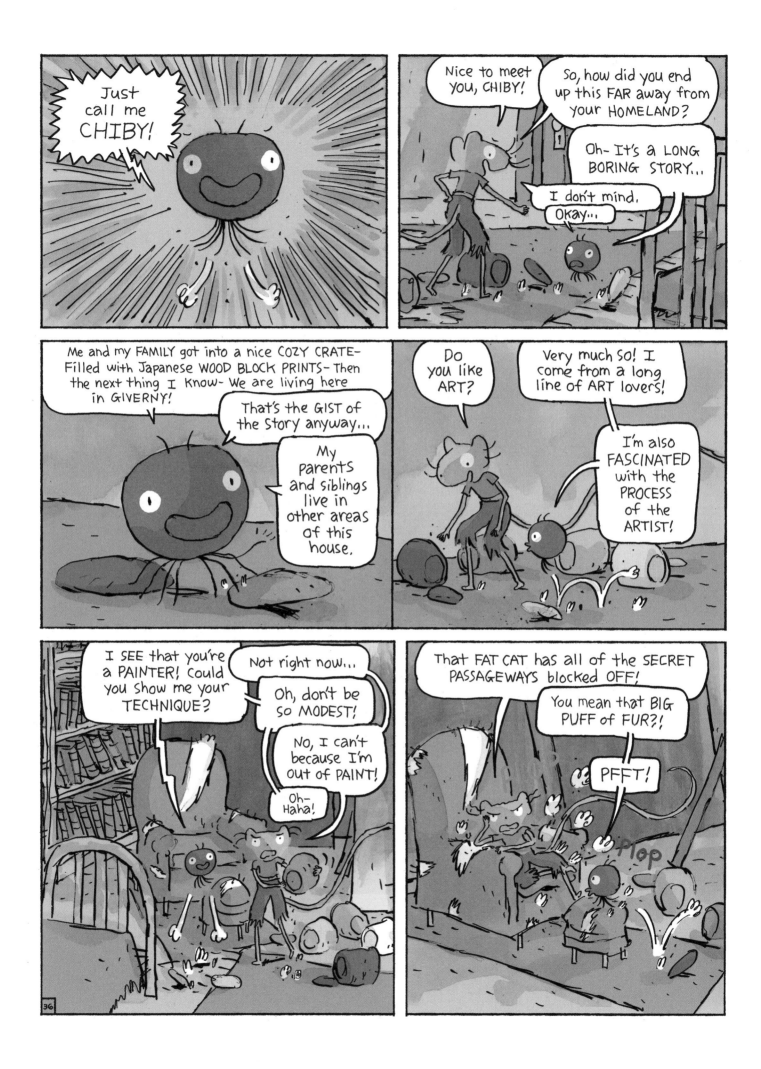

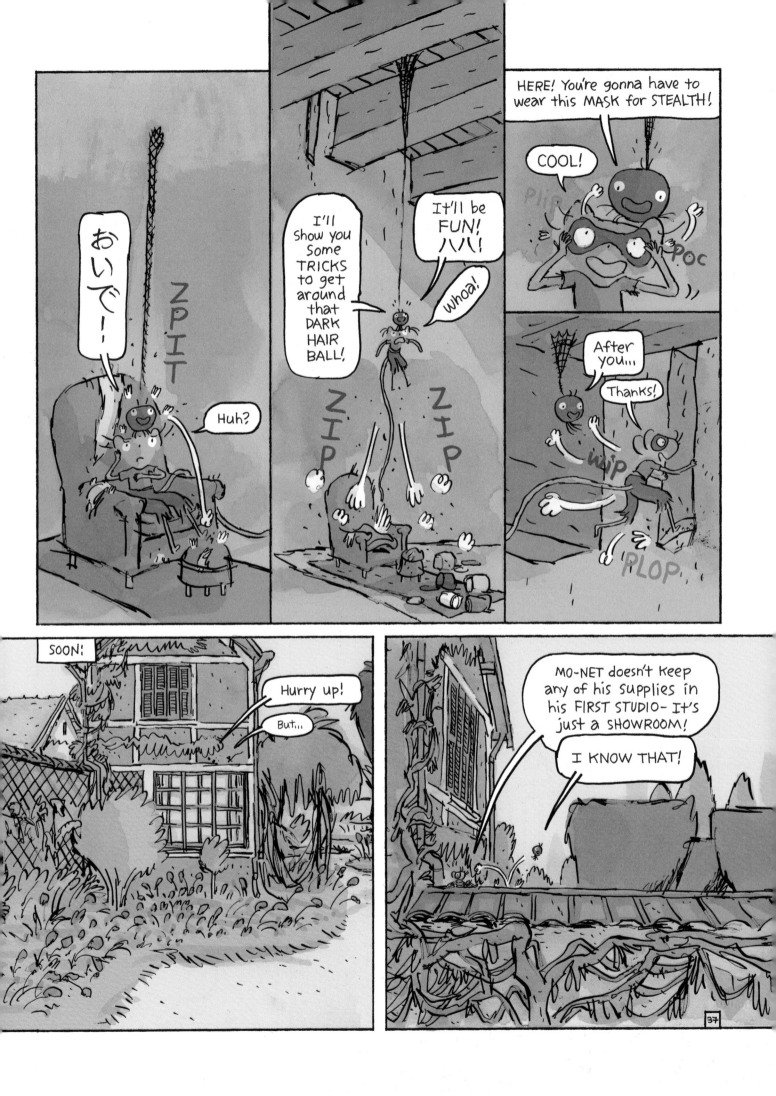

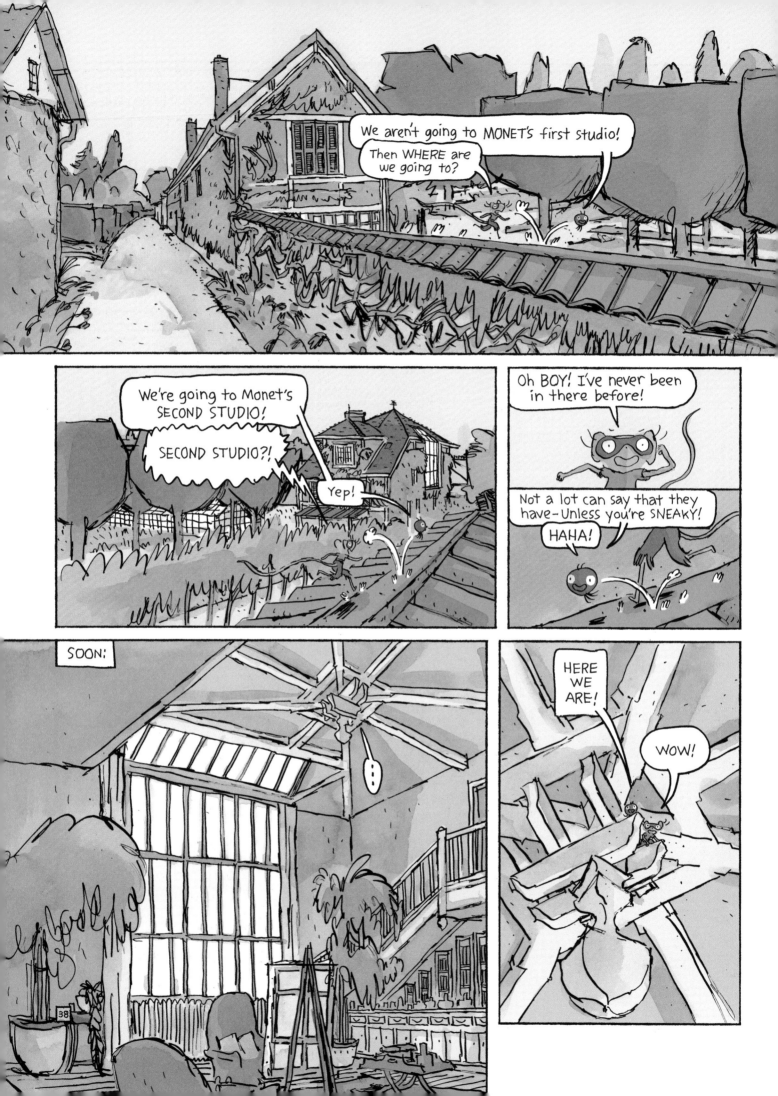

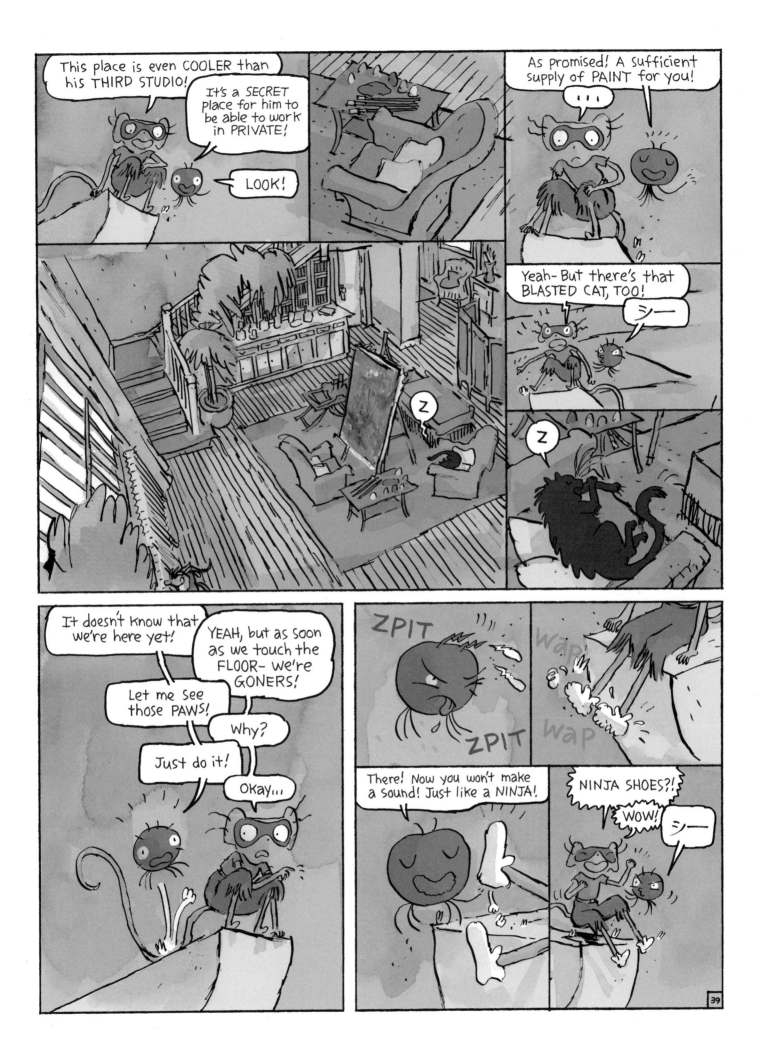

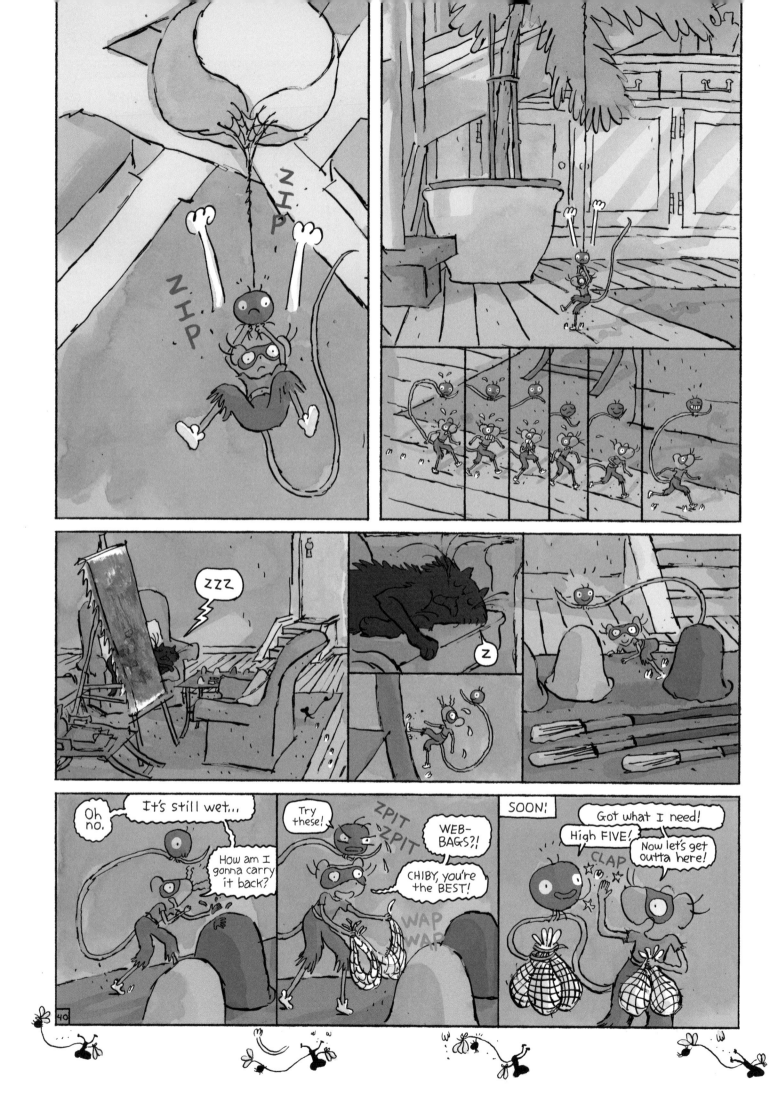

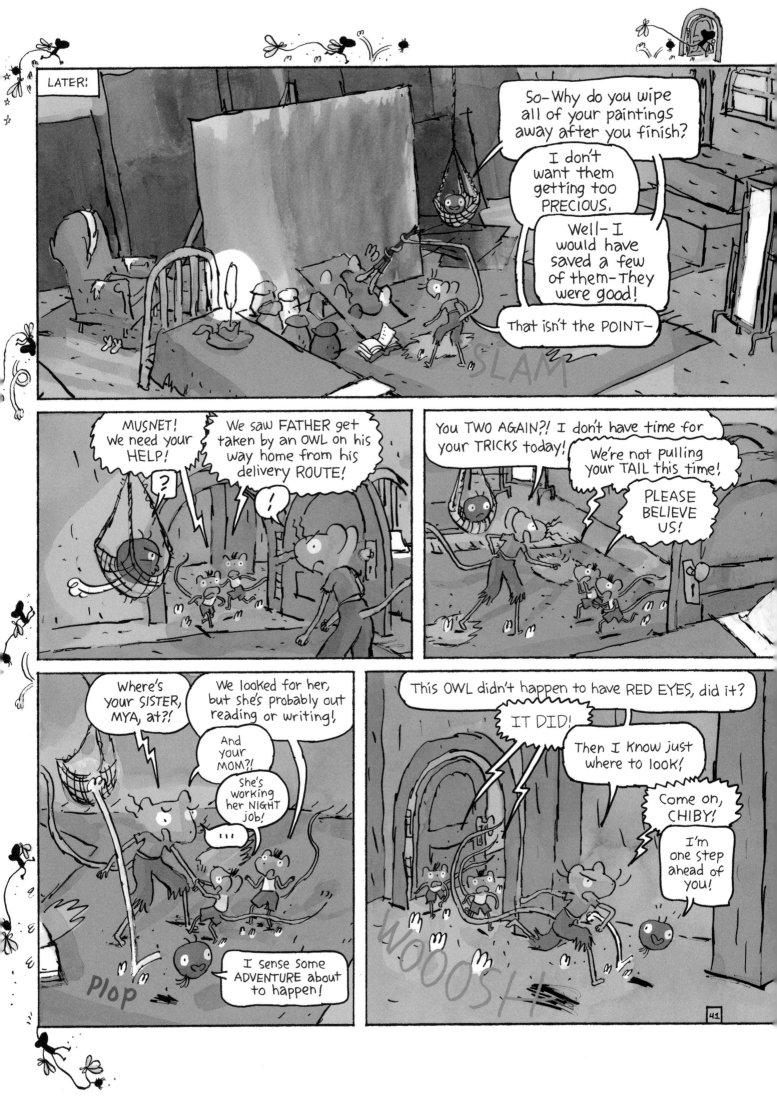

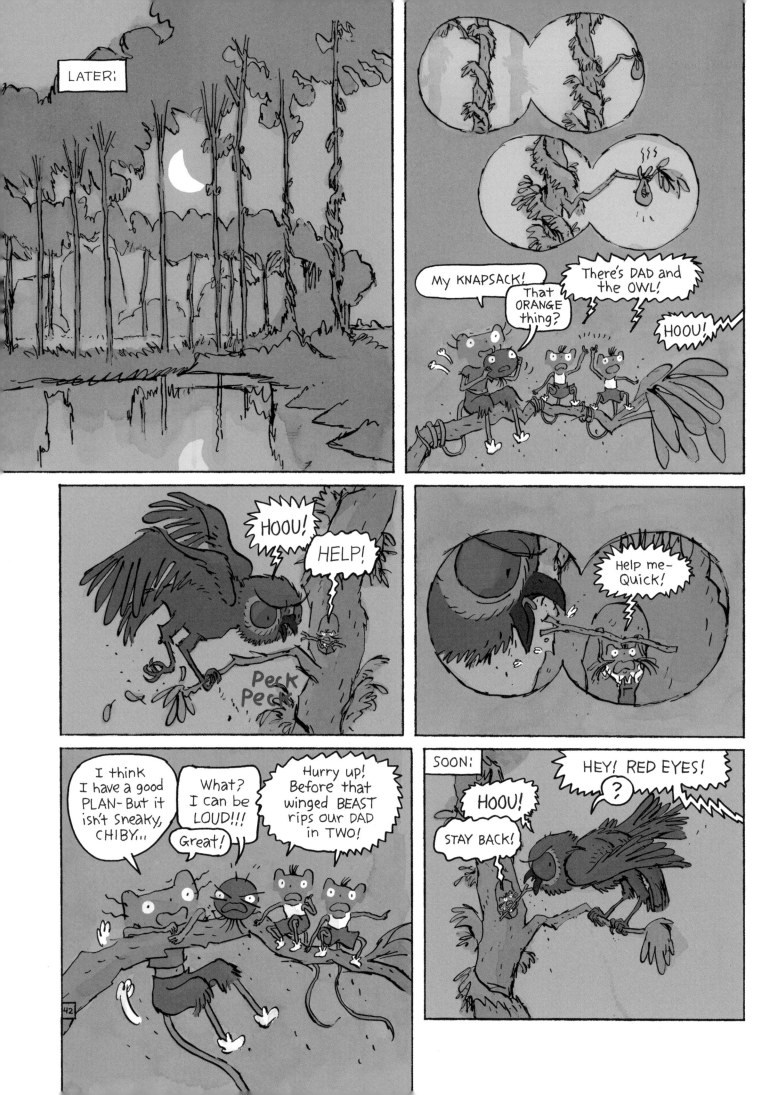

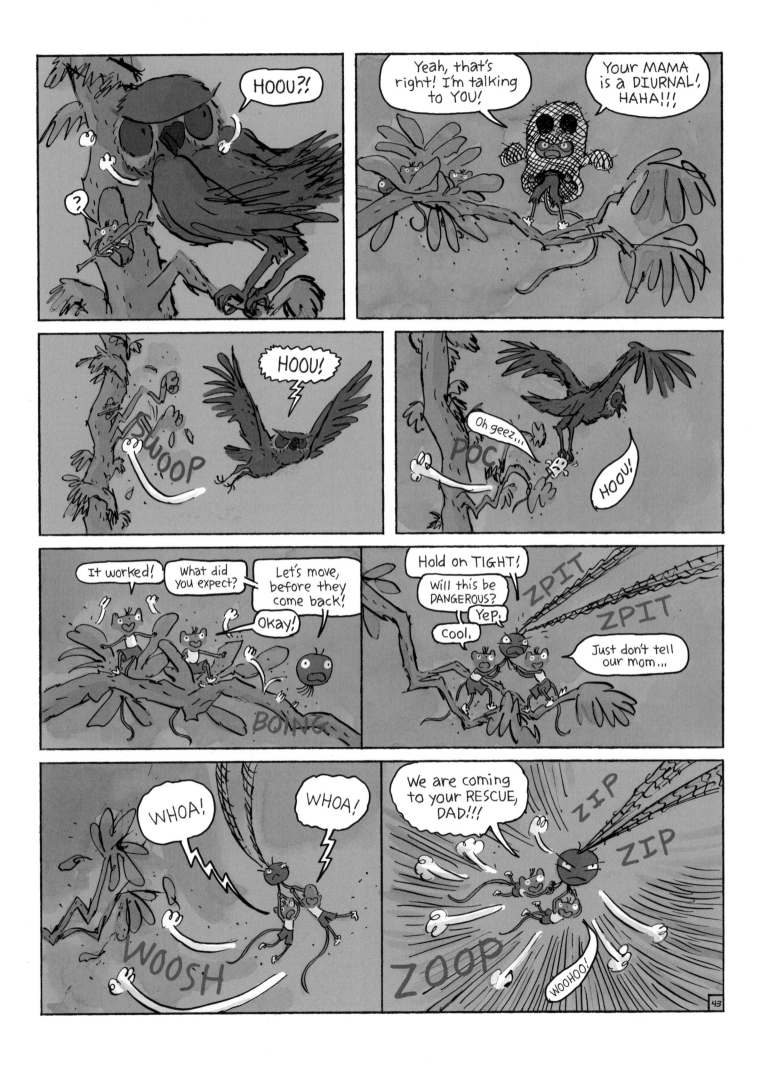

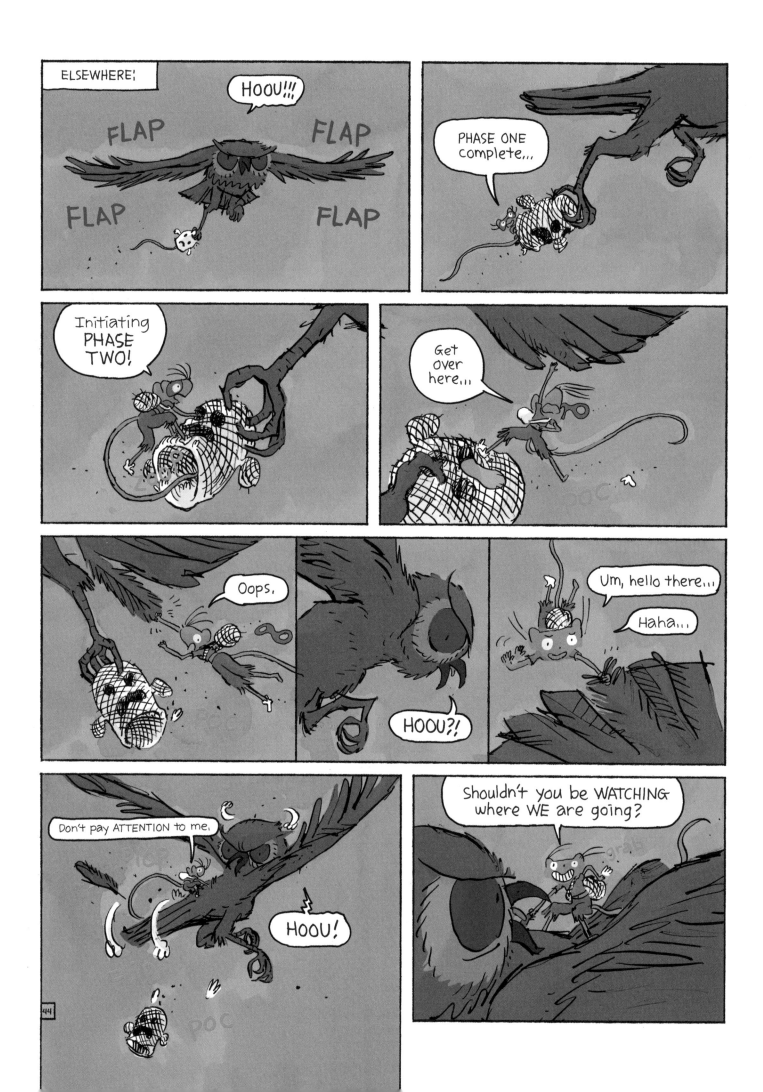

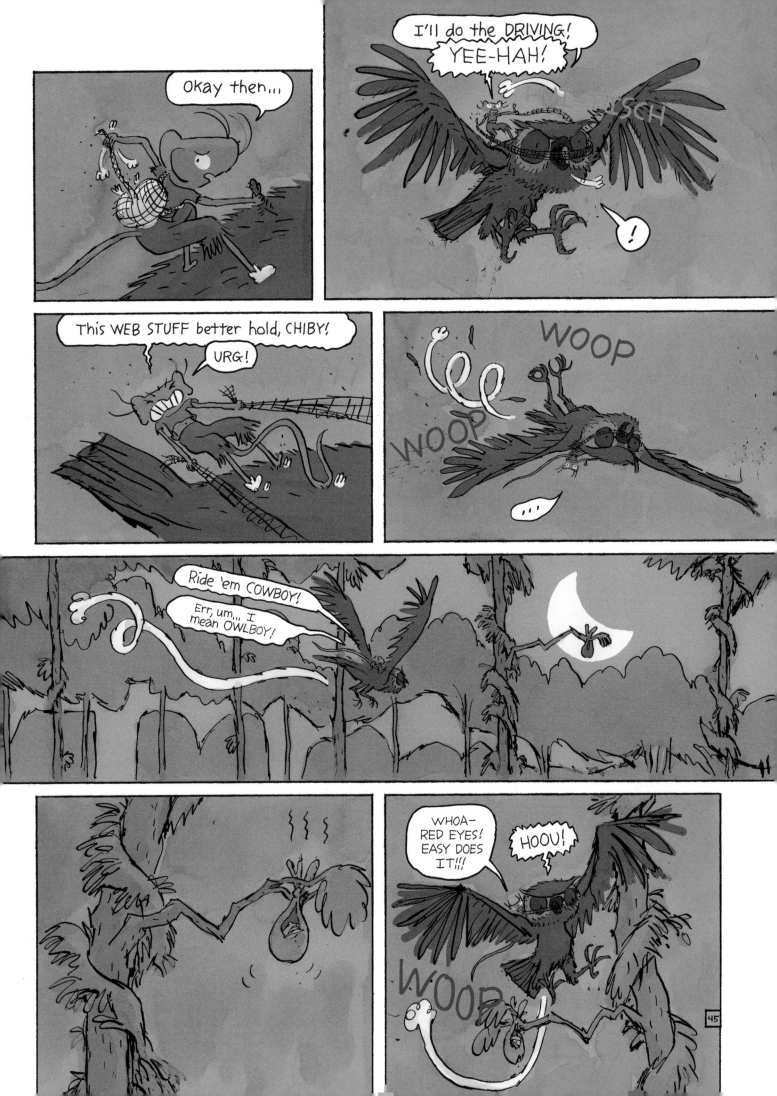

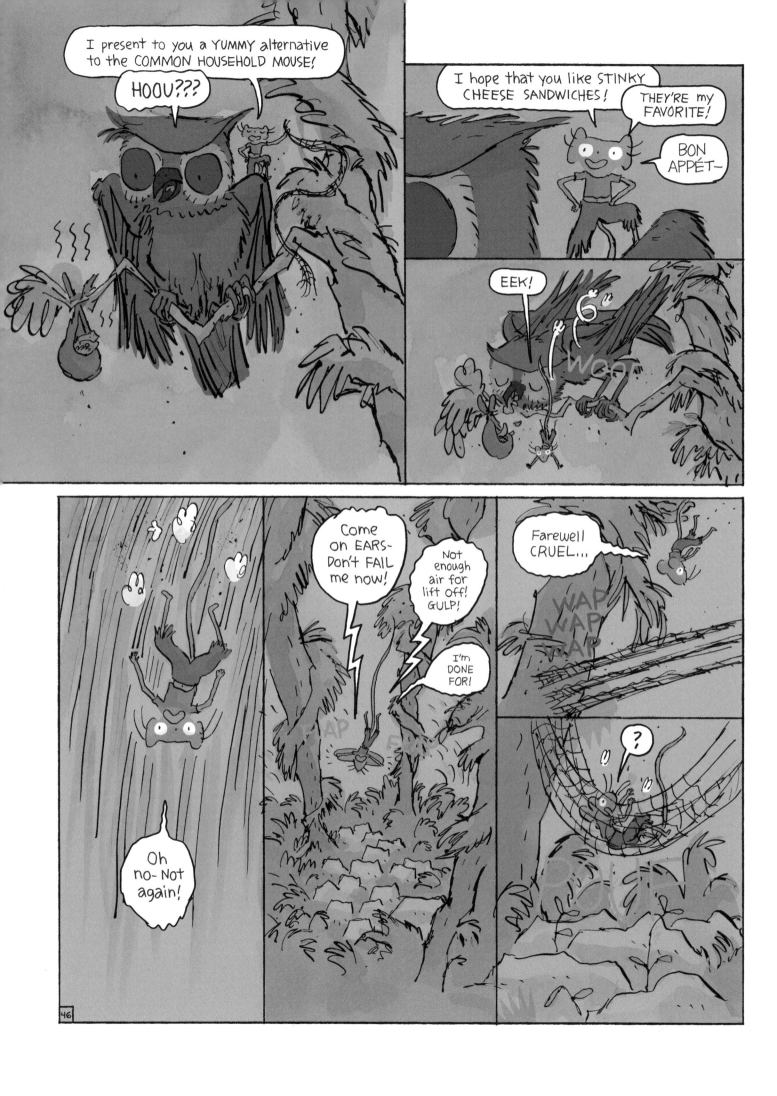

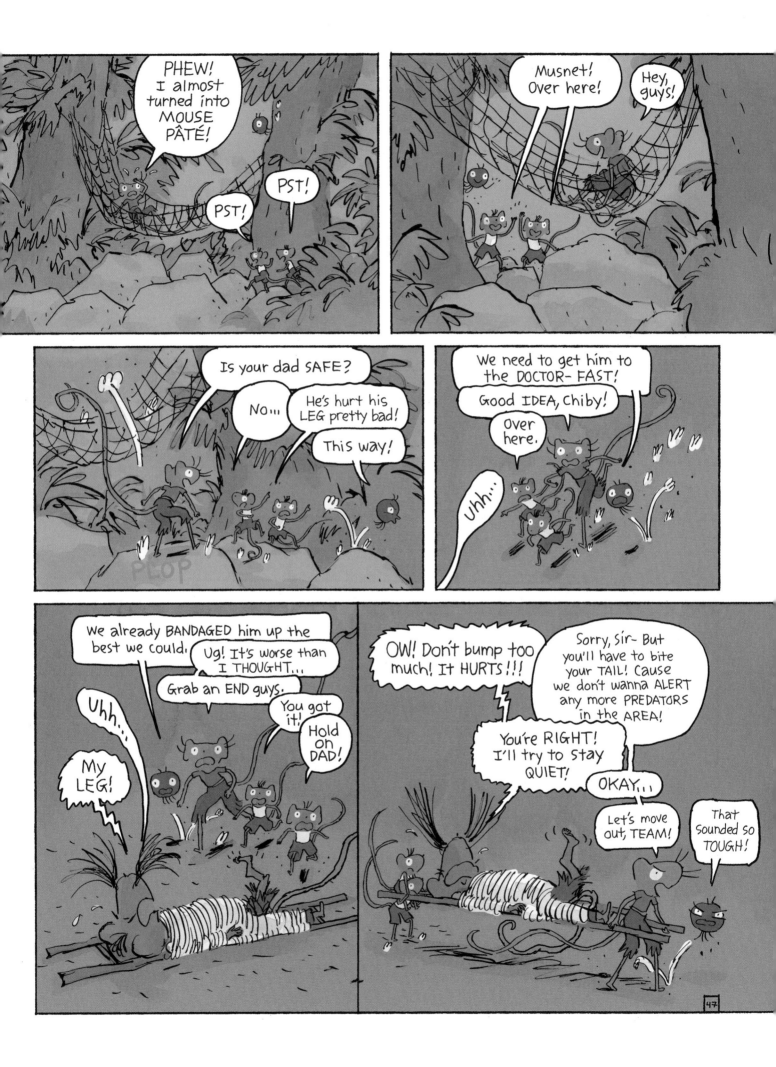

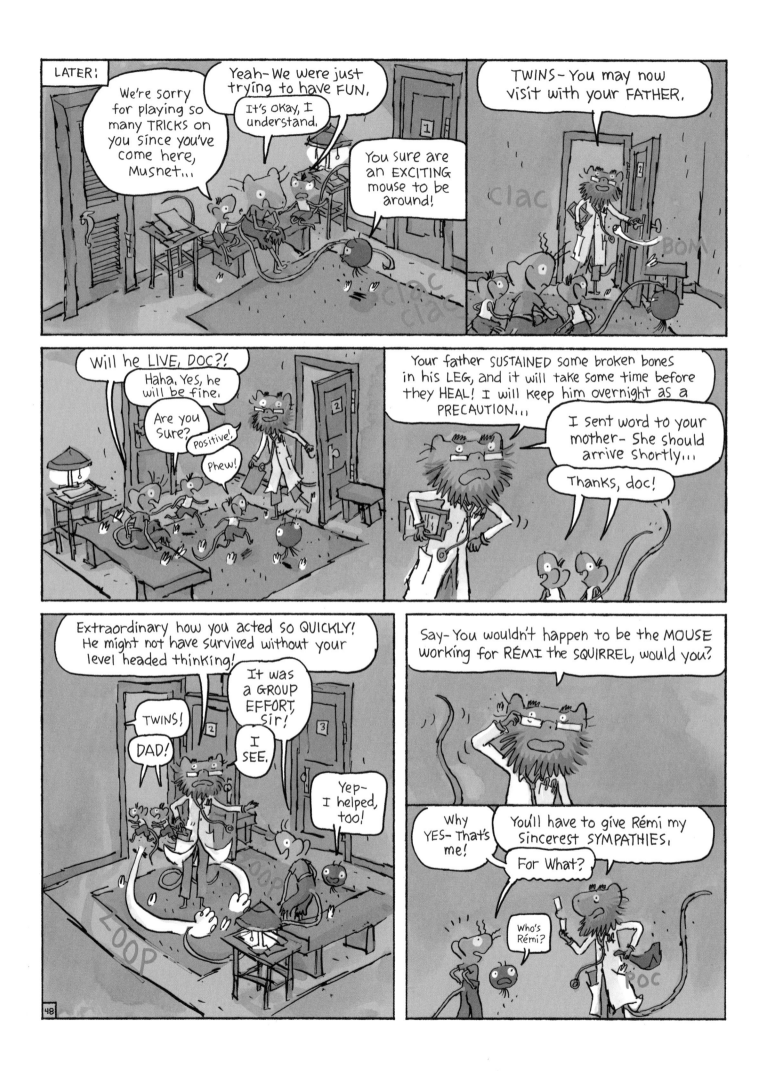

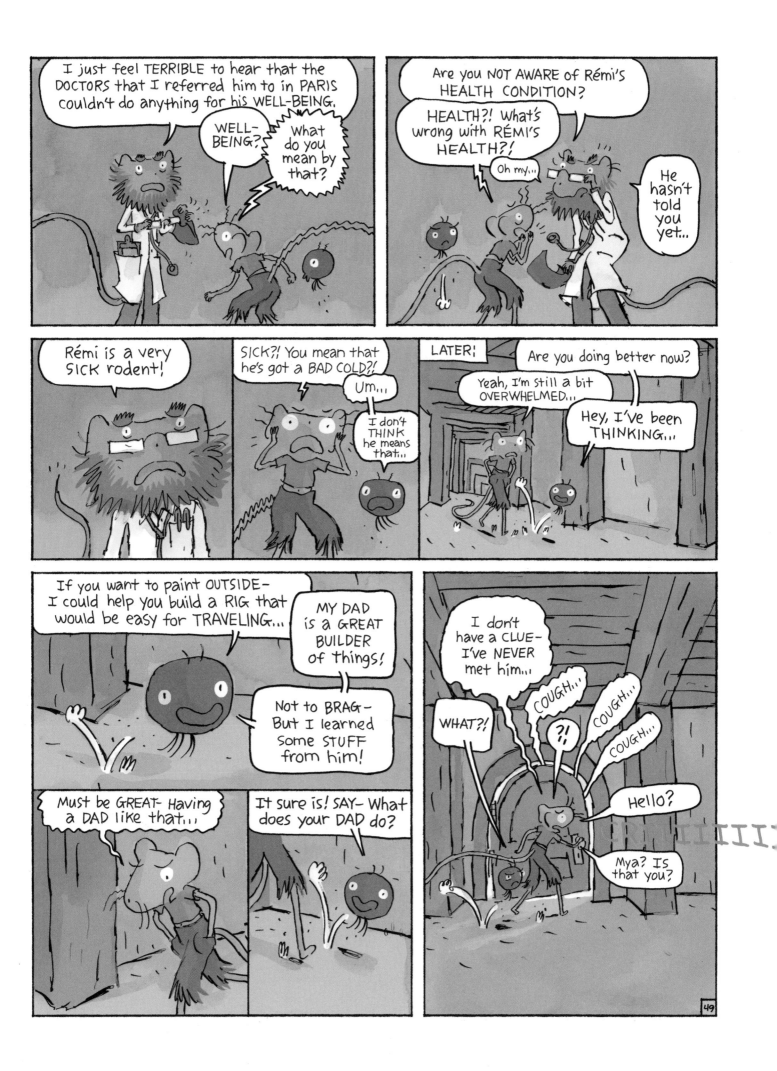

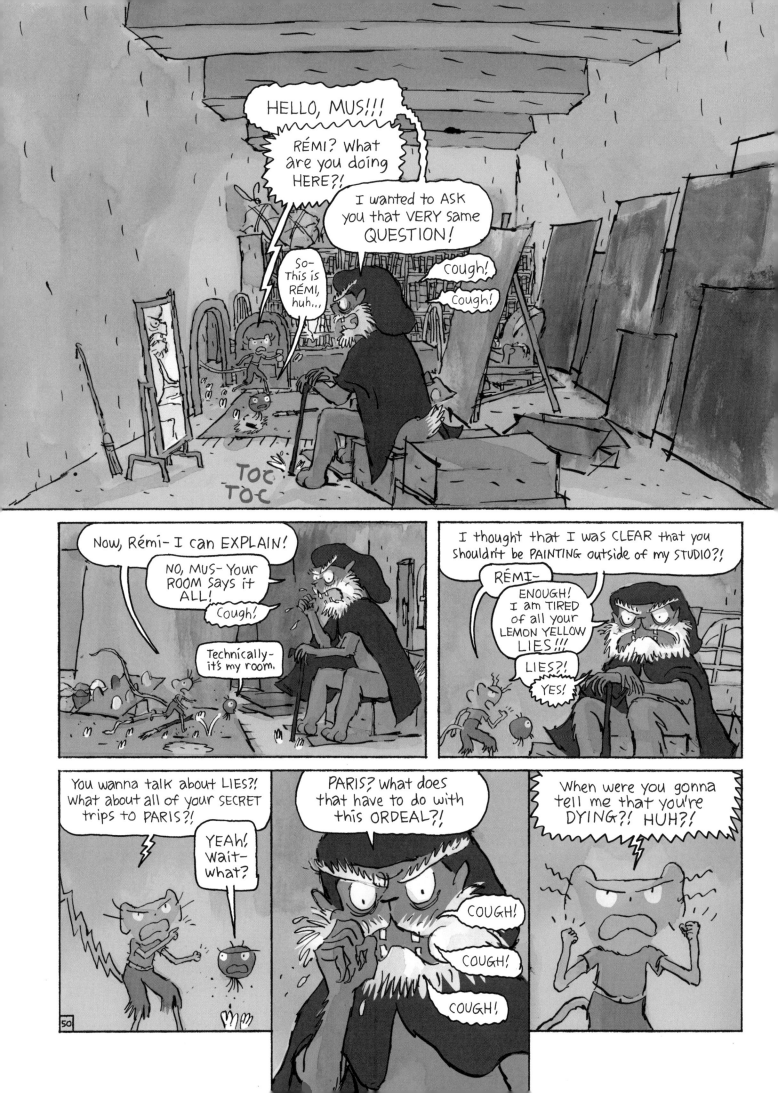

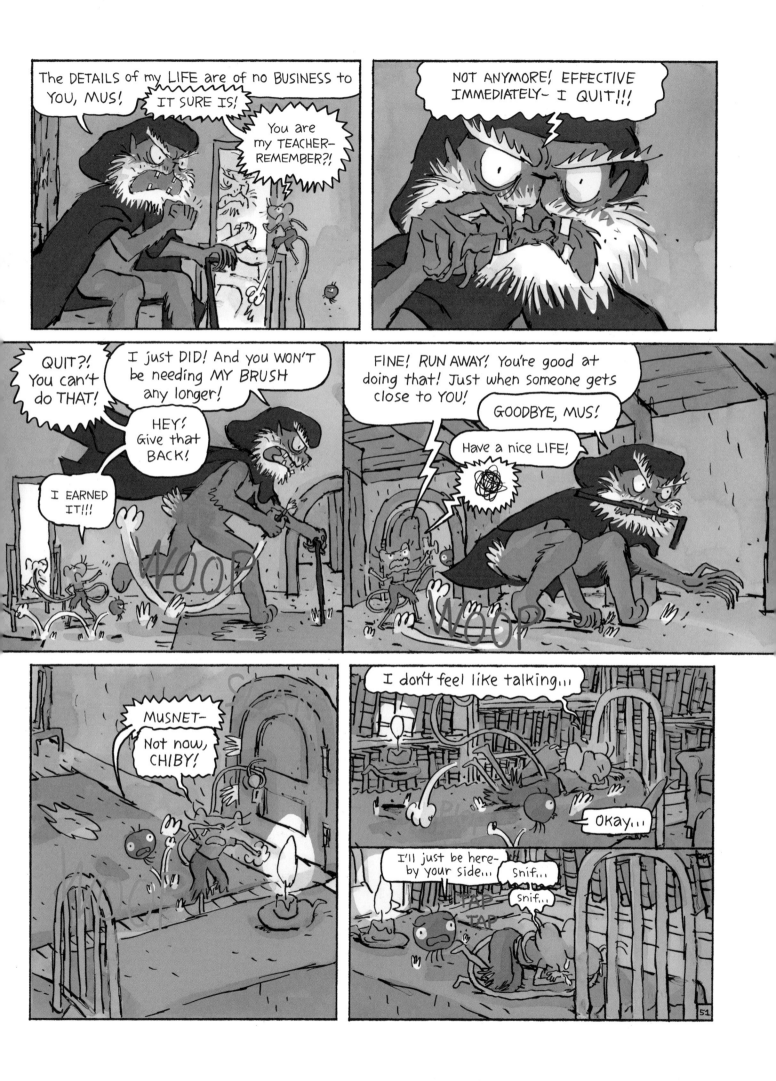

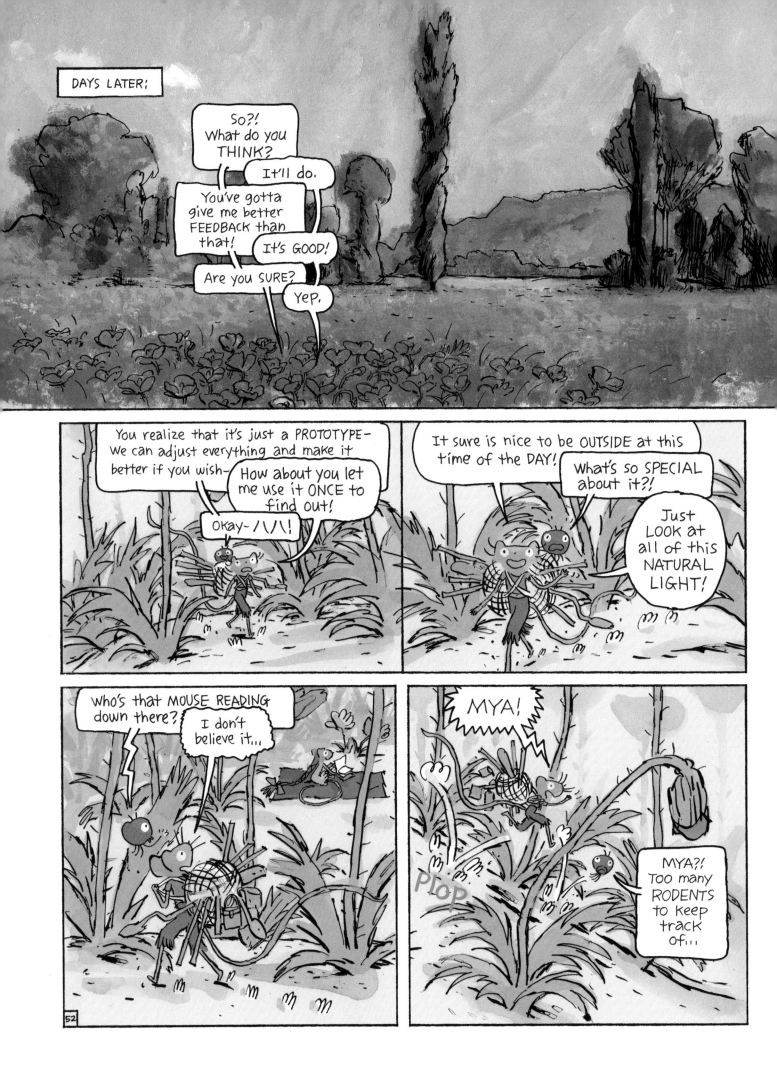

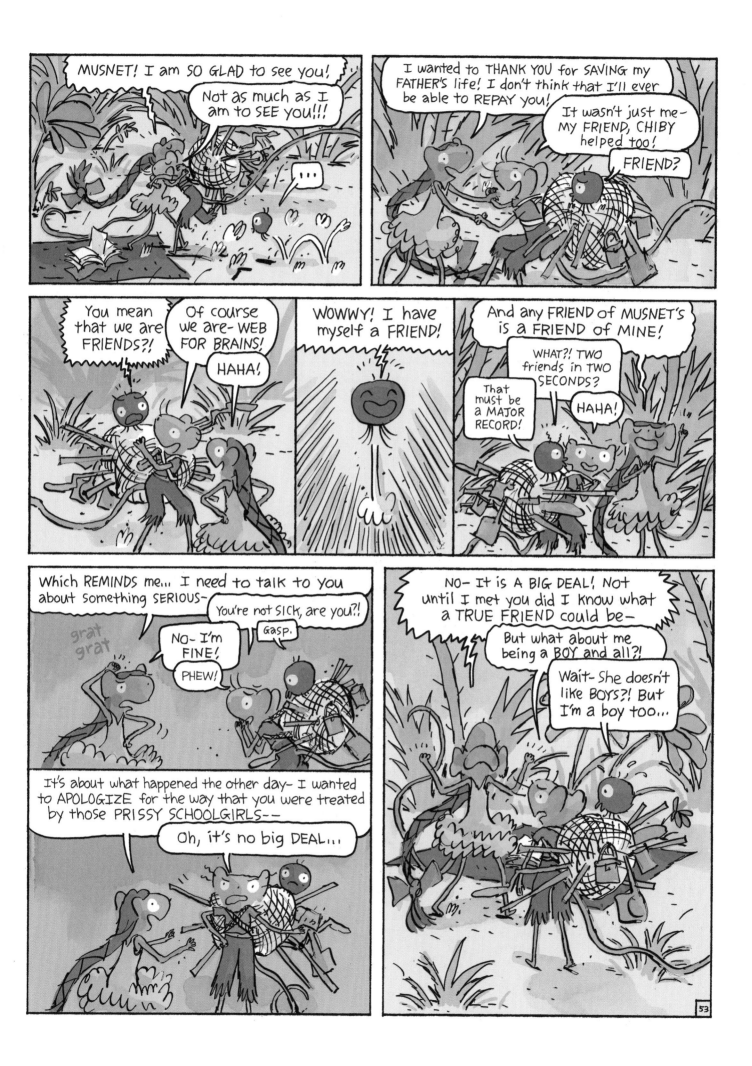

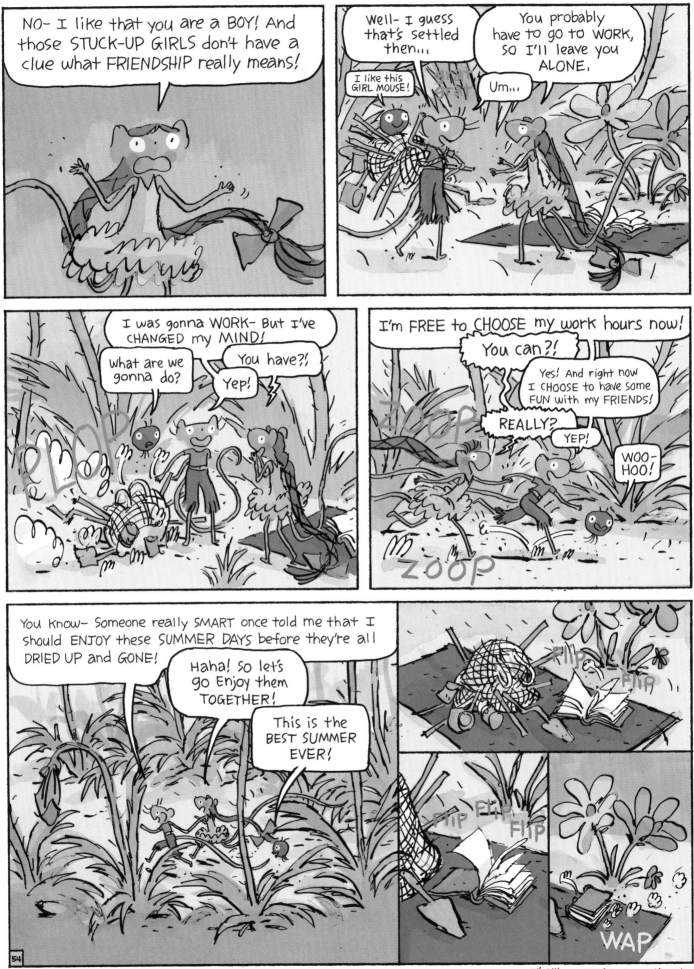

NO— I like that you are a BOY! And those STUCK-UP GIRLS don't have a clue what FRIENDSHIP really means!

Well— I guess that's settled then...

You probably have to go to WORK, so I'll leave you ALONE.

I like this GIRL MOUSE!

Um...,

I was gonna WORK— But I've CHANGED my MIND!

What are we gonna do?

You have?!

Yep!

PLOP

I'm FREE to CHOOSE my work hours now!

You can?!

Yes! And right now I CHOOSE to have some FUN with my FRIENDS!

REALLY?

YEP!

WOO-HOO!

ZOOP

ZOOP

You know— Someone really SMART once told me that I should ENJOY these SUMMER DAYS before they're all DRIED UP and GONE!

Haha! So let's go ENJOY them TOGETHER!

This is the BEST SUMMER EVER!

FLIP

FLIP

FLIP FLIP FLIP

WAP

54

kikkik 6-2016 to be continued...